takashi murakami

takashi

Center for Curatorial Studies Museum, Bard College,
in association with Harry N. Abrams, Inc., Publishers

murakami

the meaning of the nonsense of the meaning

Amada Cruz

Midori Matsui

Dana Friis-Hansen

takashi
notakashi
notakashi
notakashi

Published on the occasion of the exhibition
Takashi Murakami: The Meaning of the Nonsense of the Meaning,
presented at the Center for Curatorial Studies Museum, Bard College,
Annandale-on-Hudson, New York, June 27– September 12, 1999

Edited by Store A
Design by Takaya Goto

Library of Congress Catalog Card Number 99-75321
ISBN 0-8109-6702-2
Distributed in 2000 by Harry N. Abrams, Incorporated, New York
Printed and bound by Zincografica U.S.A.

Harry N. Abrams, Inc.
100 Fifth Avenue
New York, NY 10011
www.abramsbooks.com

murakami
murakami
murakami
murakami

imi no muimi no imi (Japanese) **=** *the meaning of the nonsense of the meaning* (English)

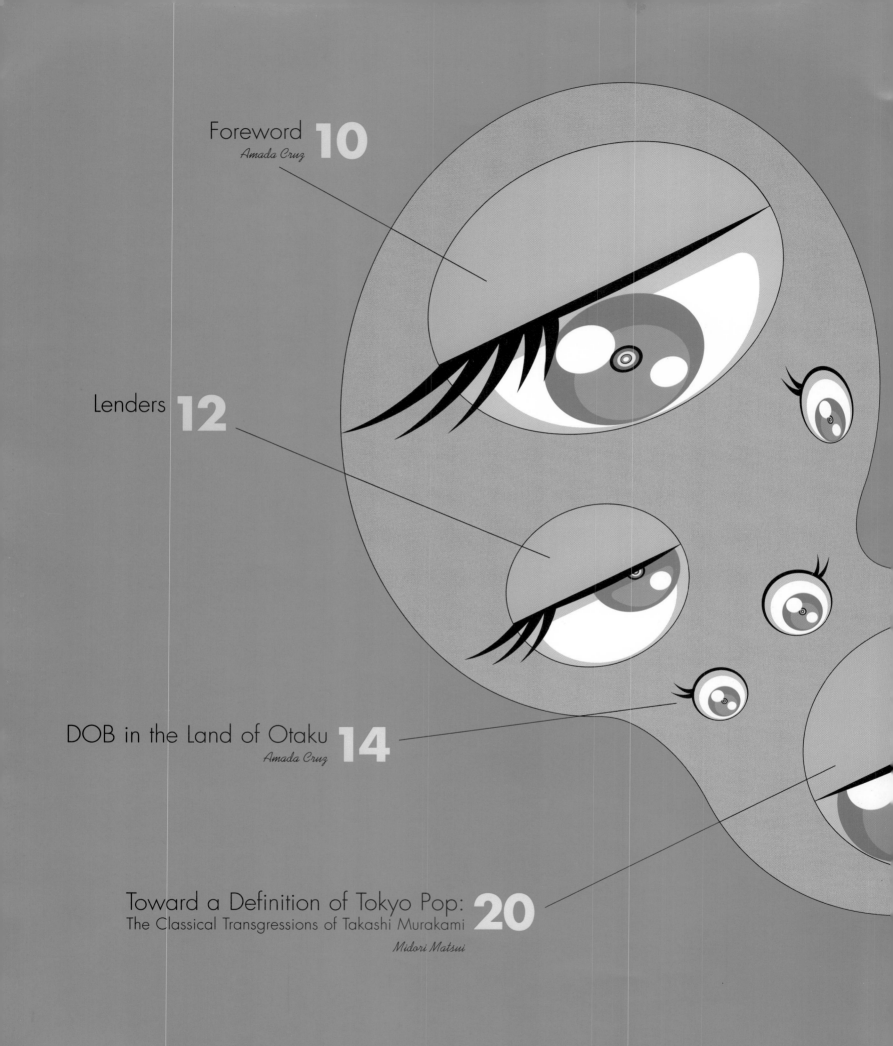

Foreword **10**
Amada Cruz

Lenders **12**

DOB in the Land of Otaku **14**
Amada Cruz

Toward a Definition of Tokyo Pop: **20**
The Classical Transgressions of Takashi Murakami
Midori Matsui

Contents

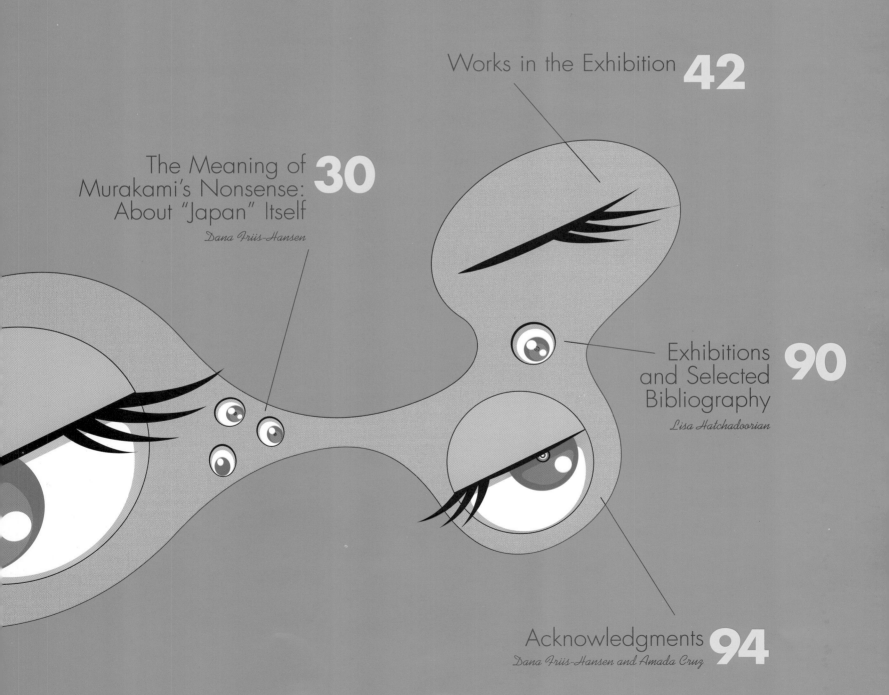

Works in the Exhibition **42**

The Meaning of **30**
Murakami's Nonsense:
About "Japan" Itself
Dana Friis-Hansen

Exhibitions **90**
and Selected
Bibliography
Lisa Hatchadoorian

Acknowledgments **94**
Dana Friis-Hansen and Amada Cruz

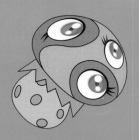
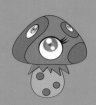

Foreword

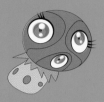
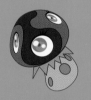
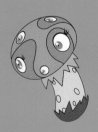

The Center for Curatorial Studies Museum is proud to present the first comprehensive survey of the work of Takashi Murakami. Murakami's art presents a hybrid of forms that speaks as much to Japanese artistic traditions as to American styles and movements. His work specifically draws upon the history of Japan as a closed environment until the opening of its borders in the late nineteenth century, the reconstruction of Japan by America after World War II, and the internationalization of American culture as technology carries us into the next millennium. Murakami's art reflects the multilayered, almost schizophrenic facets of contemporary culture as it references the venerated Japanese woodblock master Katsushika Hokusai, the Pop genius Andy Warhol, and the Abstract Expressionist icon Jackson Pollock. Murakami's body of work is also steeped in the excesses and burgeoning sexuality of an obsessed Japanese youth culture, as seen in the immensely popular *anime* (Japanese animation) and *manga* (Japanese comic books). With acute sensibility and astute perception,

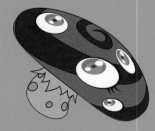

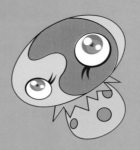
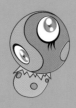

Murakami delves into the ultimate meaning behind the slick nonsense and meaninglessness of contemporary culture. Responding to the basic consumer's lusty appetite for the next big thing, he raises his products to the level of art, the ultimate delicacy for a hungry world.

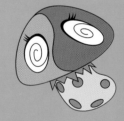

There are many people to thank for helping bring Murakami's work to the public through this exhibition and catalogue. Foremost among them are new friends of the Center, Vicki and Kent A. Logan, whose major support has made this catalogue possible. We are grateful to the Center's founder, Marieluise Hessel, for her continued commitment to the Museum's programming and for contributing additional funds for this exhibition. The Japan Foundation provided early support for the project, and we are honored to have their endorsement. Finally, our gratitude goes to the various private lenders, galleries and institutions that shared their works of art for this unique event.

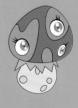

Amada Cruz, *Director*
Center for Curatorial Studies Museum

This exhibition is made possible by the generous support of the Vicki and Kent A. Logan Family Foundation, Marieluise Hessel, and the Japan Foundation.

Lenders

Ruth and Jacob Bloom, Beverly Hills

Blum & Poe, Santa Monica

Barry Blumberg, Los Angeles

Marianne Boesky Gallery, New York

Kenneth L. Freed, Boston

Tsutomu Ikeuchi, Tokyo

Pauline Karpidas, London

Kim and John Knight, Larkspur, California

Tomio Koyama Gallery, Tokyo

Vicki and Kent A. Logan, San Francisco

Curt Marcus, New York

Marunuma Art Park, Saitama-ken, Japan

Stavros Merjos, Venice, California

Hisanao Minoura Collection, Aichi, Japan

Misawa Art Project, Shizuoka, Japan

Salucoro Mizutani, Tokyo

Takashi Murakami, New York and Tokyo

Neuberger Berman, LLC, New York

Eileen and Peter Norton, Santa Monica

Private Collection, London

Jason and Michelle Rubell, Miami Beach

San Francisco Museum of Modern Art

Ann and Mel Schaffer Family Collection, New Jersey

Darryl Schweber, New York

Shinichi Shimizu, Gunma, Japan

Roderic Steinkamp, New York

Ryutaro Takahashi, Tokyo

DOB in the land of
OTAKU

Amada Cruz

Takashi Murakami's Pop-infused art portrays Japan's contemporary culture as a hyper-consumer realm that appears so familiar to Americans and yet is steeped in ancient traditions. His all-too-cute work, which ranges from paintings and sculptures to watches and do-it-yourself kits, challenges the distinctions between fine and hobby art. His work so perfectly mimics consumer obsessions that it embodies all the ambiguities and contradictions inherent in those tropes. But, as Murakami has stated, he is less interested in revealing media strategies than are other artists of his generation.[1] With his uncanny ability to mirror his culture he is more the Japanese equivalent of Andy Warhol than someone intent on critiquing things.

A case in point is Murakami's 1994 *Kase Taishuu Project* (pl. 5). It began as a real-life incident in which a popular Japanese television star lost the right to use his name in a dispute with his manager. Unwilling to abandon a profitable formula, the manager subsequently presented another entertainer as the new Kase Taishuu. Inspired by the absurdity of the situation, Murakami recruited four art students to pose as additional Kase Taishuus, marketing them so successfully that magazines and a television newscast ran stories about them. The ruse continued until members of the Japanese mafia paid Murakami a visit to request that he stop using the valuable name.[2] As Midori Matsui has written, by so closely copying the original, Murakami's project worked as "an exposure of the ideological consumer apparatus through the exploitation of its mechanism."[3] Warhol performed a similar although less strategic prank in 1967, when he sent the actor Allen Midgette out on a successful five-college lecture tour as Andy Warhol. The hoax went undiscovered for a year until *Time* magazine disclosed it in an article, and the real Andy Warhol had to retrace the lecture circuit to make amends.[4]

In contrast to Murakami's Kase Taishuu impostors, who knowingly parodied an existing example, Warhol's Superstars, such as Edie Sedgwick and Viva, performed as actors in his original films. Perhaps as a reflection of those less self-conscious times, Warhol and his collaborators pioneered the independent film genre instead of offering a critique of Hollywood. Rather than duplicate and mock a manufactured celebrity, they played themselves according to Warhol's directions, and in the process became famous. Just as Warhol invented the celebrity of his coterie, today the media and public promote the fame of mediocre actors and dubious stars. Murakami's *Kase Taishuu Project* is an affirmation of Warhol's well-known prediction of celebrity for all. Murakami acknowledges his debt to Warhol by portraying his four Kase Taishuu holding bananas, a reference to the Pop artist's cover design for the Velvet Underground's debut album, *Velvet Underground and Nico*.

Murakami's interest in film dates back to his childhood desire to become an animation director. Since he suspected he did not have the talent to pursue this course, Murakami enrolled in art school to study *nihon-ga*. A hybrid of Eastern and Western painting developed in the Meiji Era (1868–1912), during Japan's modernization, *nihon-ga* combines the traditional Japanese painting style of the earlier Edo period with modern Western techniques and styles.[5] Murakami incorporates his training in *nihon-ga*

1 Takashi Murakami in "Takashi Murakami with Midori Matsui," *Index* 3 (November/December 1998): 48.

2 In conversation with the artist, February 22, 1999.

3 Midori Matsui, "Murakami Takashi: Nihilist Agonistes," in *Takashi Murakami: Which Is Tomorrow?—Fall in Love* (Tokyo: SCAI The Bathhouse, 1994): 41.

4 Victor Bockris, *The Life and Death of Andy Warhol* (New York: Bantam Books, 1990): 223.

5 Noi Sawaragi, "Takashi Murakami," *World Art* (Summer 1997): 76.

6 In conversation with the artist, February 22, 1999.

7 Antonia Levi, *Samurai from Outer Space: Understanding Japanese Animation* (Chicago and LaSalle: Open Court, 1996): 1.

8 Frederik L. Schodt, *Dreamland Japan: Writings on Modern Manga* (Berkeley: Stone Bridge Press, 1996): 275.

9 Murakami, *Index*: 47.

10 Ibid.

11 In conversation with the artist, February 23, 1999.

12 John Whittier Treat, "Yoshimoto Banana Writes Home: The Shojo in Japanese Popular Culture," in John Whittier Treat, ed., *Contemporary Japan and Popular Culture* (Surrey: Curzon Press, 1996): 283–84.

13 In conversation with the artist, February 23, 1999.

14 In conversation with the artist, February 22, 1999.

with his continuing preoccupation with *anime*, or Japanese animation, all the while that he continues to harbor the ambition of directing an animated film.[6]

While the majority of American animation productions are aimed at children, Japanese animated films have much broader audience appeal. As Antonia Levi points out, *anime* is a French word that the Japanese use to describe all animation, and Americans in turn use it to describe Japanese animation.[7] *Anime* was originally developed from American precedents— particularly Disney. The output of the Japanese industry is now larger than that of the United States and Europe combined,[8] and films are regularly exported to the United States. Popular *anime* directors are revered as great artists, and aggressive product merchandising magnifies a film's impact as well as its profits. *Anime* has achieved cult popularity in the United States, with many fan clubs on university campuses and countless websites devoted to it.

Murakami is fascinated with *anime* less for its high-tech illusionism than for the old-fashioned sense it provides of watching drawings in motion. "To see drawings move is a totally different experience than looking at computer graphics. I love drawings."[9] The *anime* production system is also an influence: "When I saw that animation films had a coherent system of production, I realized that there was a field that allowed you to draw all the time and also enabled you to function in society."[10] Murakami's own studio resembles a small animation set-up, with his many assistants (twelve on a recent visit) divided between two sheds, one for painting and one for computer production. Murakami's assistants help with all aspects of his artistic output, including the paintings and merchandise, which he releases under his studio's name, Hiropon Factory. The name is a nod to Warhol and his infamous Factory, where a changing cast of characters similarly assisted him in his varied activities.

Like that of his Pop predecessor, Murakami's embrace of the marketplace is enthusiastic. Another filmmaker he admires is George Lucas, the creator of the *Star Wars* films. Lucas is an inspiration for his innovative computer effects and for his foresight in copyrighting his characters, an extremely lucrative business strategy that has allowed him to finance his films. Murakami's own registered character, DOB, has become so popular that there are barely altered counterfeits currently circulating due to the fact that Japan's lax copyright laws go unenforced in a society that shuns litigation.[11] Murakami's uncritical stance toward capitalism is perhaps typical of his generation. In a study of the role of young women in contemporary Japanese society, John Whittier Treat states that the current generation has been chastised for its lack of countercultural protest in the face of rampant consumerism. But, citing Frederic Jameson, Treat suggests that how one functions within popular culture is a complex matter with myriad possibilities for opposition.[12] While in the United States cultural insurgency is associated with an anticapitalist, Marxist attitude, in Japan to have success within the mass culture as an independent producer of works that hail from the subculture of *anime* fandom may be an equally valid form of resistance.

Murakami's motivations for working within the market are clear, as he sees no distinction between his fine art and his merchandise.[13] His goal is to speak to and about current Japanese society by creating and distributing works that are understood by all. DOB derived from Murakami's efforts to find an image or concept that was "originally Japanese." He elicited ideas for an upcoming exhibition by asking friends what they thought was hip. He rejected an initial suggestion of surfboards as too American and decided that the ubiquitous promotional characters so visible in Tokyo would be more authentic.[14] Well aware of the vast American influence on postwar Japan, Murakami was ironically unaware at the time that this marketing technique originated with American advertisers.

Although he resembles Mickey Mouse, DOB is for the most part modeled after a monkeylike figure from Hong Kong, and is deliberately cute and silly looking in the typical big-eyed style of Japanese cartoon characters. DOB debuted as a painting in 1993 but, much to the artist's surprise, was not well received. Murakami had wanted to create a work "with no meaning" that would resonate with a

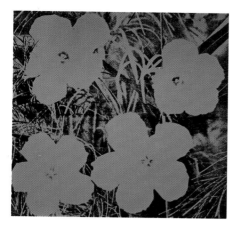

fig. 1 Andy Warhol, *Flowers*, 1967
Silkscreen ink and synthetic polymer paint on canvas
115 1/2 x 115 1/2 in. (293 x 293 cm)
Collection Museum of Contemporary Art, San Diego,
Museum purchase with contributions from
the Museum Art Council Fund (1981.2)

Japanese audience that devours similar images in *manga*, Japanese comic books.[15] As with the earlier *Kase Taishuu Project*, the copy may have been too seamless. DOB has subsequently appeared in an ongoing series of works, from paintings to balloons to plush toys and watches. Murakami has morphed DOB from its earliest, more conventional representation into seemingly endless permutations, including an inflatable, multi-eyed, teeth-baring monstrosity; linked and duplicated strands of DNA; and bubble-like disks floating against a field of color. DOB is now a popular success: as Murakami says, DOB is "walking by himself....The character is very strong." His importance to Murakami is based on his ability to communicate to his viewers. "[The] audience [doesn't] need the artist, only the character."[16]

Although he hails from the world of marketing, DOB does not promote any product, except perhaps Murakami. DOB is a disengaged signifier, an ever-changing symbol of all the other artificially constructed characters that sell merchandise. Writing on Japanese consumerism, Marilyn Ivy compares recent Japanese advertising to the more classical strategy of contrasting products. She asserts that there is a new pattern, "symbolic product differentiation," whereby advertisers promote the distinctions between their wares symbolically, since functionally there is little difference between them. Ivy quotes Asada Akira, who explains the trend: "When this reaches its furthest development,...the product ends up disappearing and only the symbolic images which surround the business, the product, or the brand, remain."[17] Ivy maintains that this phenomenon is appropriate to Japan, "in a culture where the notion of the origin, it is said, has not existed: where there is no transcendental signified."[18] The most often cited example of this lack of the concept of the original is the ancient Ise Shrine, which is entirely rebuilt every twenty years. Although they are reconstructions, the new buildings are considered no less authentic because they are built in a special architectural style that can only be used for the Ise Shrine.

Another way of looking at Murakami's co-optation of consumer images is to regard it as the only response to a society dominated by them.

Comparing Warhol to Charles Baudelaire, Jean Baudrillard describes the connecting theme as that of "absolute merchandise."[19] According to Baudrillard, in the face of commercialization and its threat to objectify art, Baudelaire found that the only solution was for art to "become more mercantile than merchandise itself."[20] Art should rid itself of its traditional aura and authority and bask "in the pure obscenity of being merchandise."[21] For Baudrillard, Warhol was the artist who was most successful in this pursuit. "He [went] farthest with the ritualized, negative transparency of art, its utter indifference to its own authority."[22]

Murakami also goes far in "sanctifying art as merchandise,"[23] but an important difference is his meticulous craftsmanship. While Warhol's paintings reveal the accidents of the silkscreen process, Murakami's works are carefully painted by himself and his skilled assistants with the exactitude of his rigorous formal training and the perfection of the computer drawings that serve as studies. A comparison of the flower paintings of both artists reveals other significant differences. Warhol's earliest series of *Flowers*, begun in 1964 (fig. 1), originated from a photograph of poppies in a magazine. He and an assistant transferred the image onto numerous canvases via silkscreen. The inevitable bleeding of one color into another is apparent in each painting and is enhanced through the use of vibrant color. The flatness of the forms pushes the images toward abstraction. The flowers appear frozen in time like plastic replicas, so much so that when they were first exhibited, many critics interpreted the works as having to do with death.[24]

Murakami made his earliest flower painting, *Cosmos*, in 1995. Looking as if they were rendered by a precocious child, the flowers have the goofy smiles of cartoons. As with all of Murakami's paintings, he and his assistants worked from computer drawings and hand painted the images onto canvases. As did Warhol, Murakami produced a series of paintings with the flower motif; he did not, however, repeat the same composition but only the grinning flower character, portraying it floating effortlessly across a blue sky or attached to elegantly meandering

15 In conversation with the artist, February 23, 1999.

16 Ibid.

17 Marilyn Ivy, "Critical Texts, Mass Artifacts: The Consumption of Knowledge in Postmodern Japan," Masao Miyoshi and H. D. Harootunian, eds., *Postmodernism and Japan* (Durham, N.C., and London: Duke University Press, 1989): 37.

18 Ibid., 39.

19 Jean Baudrillard, "Absolute Merchandise," in Martin Schwander, ed., *Andy Warhol: Paintings 1960–1986*, exh. cat. (Lucerne: Kunstmuseum Luzern, 1995): 18.

20 Ibid.

21 Ibid., 19.

22 Ibid., 20.

23 Ibid.

24 Bockris, 158.

pl. 40 Takashi Murakami, *Cosmos*, 1998
Acrylic on canvas on board
60 x 120 in. (150 x 300 cm)
Courtesy of the artist and Tomio Koyama Gallery, Tokyo

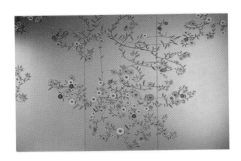

vines set against a silver background (pl. 40).
The sense of motion and character in Murakami's
paintings derives from the conventions of animation,
compared to the stillness of Warhol's, which derives
from a photograph.

Murakami's flowers exude an optimistic personality
that can only be described as cute. Like DOB, his
flowers resemble the multitude of silly marketing
icons so plentiful in Japan. Noi Sawaragi traces this
obsession with cuteness to the postwar Emperor
Hirohito, whom his subjects saw as "a cute old
man." Sawaragi claims that this attitude was a
manipulative "'rule by cuteness' rather than 'rule by
power.'" He associates this tactic with "a feminine
way of controlling" that is unrelated to feminism.[25]
Treat also relates cuteness to the feminine, more
specifically to "shojo culture" or that of the *kawaii*
(cute) girl. He explains that the *kawaii* girl's role is
to be attractive and to shop.[26] Her appealing image
is as visible in Japanese advertising as all those
promotional figurines.

If cuteness is feminine, then Murakami with his
galaxy of adorable characters can be accused of
gender-bending. His two most notorious sculptures,
Hiropon (1997, pl. 16) and *My Lonesome Cowboy*
(1998, pl. 38), raise all the complicated gender
issues of *manga* and *anime* specifically, and of
contemporary Japanese culture in general. *Hiropon*
is a larger than life cartoon fantasy with huge
manga eyes, a sweet doll face, and gravity-defying
hair. She is naked except for a useless bikini top
that barely contains hugely inflated breasts. *Hiropon*
holds her exposed nipples, from which burst copious
streams of milk that encircle her like a jump rope.
She is bottomless, revealing that she has no pubic
hair or genitalia. *Hiropon* is every *otaku*'s dream-girl.

Otaku are obsessed fans of diverse pop culture
phenomena, but most commonly of *anime* and
manga. They are a significant subculture in Japan,
where *manga* publication is a huge business,
and there is an equally large market for related
merchandise. The stereotypical *otaku* is a young
computer geek who lives for obscure *anime* trivia.
These *otaku* satisfy their (mostly sexual) fantasies

through *manga* and *anime* characters and have
little contact with women their own age. In Japan
otaku is a slightly derogatory term, but in the
United States it is used by American *anime* fans to
describe themselves.

Murakami has at times denied that he is an *otaku*:
"I am not an *otaku*. *Otakus* are pure dilettantes.
They never create anything."[27] But he has also
adopted the term to describe himself: "I am one of
the people who are categorized as *otaku*...I like to
immerse myself in thinking and talking about things
in the fantasy world that have no role in society
whatsoever."[28] The ambivalence he expresses
extends to the complex sexuality of *Hiropon*, which
is based on *manga* and *anime* conventions.
Although clearly female, *Hiropon* has no vagina.
According to Murakami, *otaku* would rather not
see female genitalia[29] and, thanks to censorship
laws that forbid their depiction, never did until
recently, since the laws have been relaxed. As if to
compensate for this lack, *Hiropon* has two penises
in the form of her nipples. Murakami borrowed this
feature from the erotic *manga* of Henmaru Machino,
who often depicts young women who sprout phalluses
from various body parts (fig. 2).[30] To fabricate
Hiropon, Murakami worked with Bome, one of
the top craftsmen who make do-it-yourself model kits
for the *anime* market. *Hiropon* is essentially one of
those models writ large. The increase in scale
became an issue for Bome, who was certain that
otaku would not appreciate it.[31] To enlarge the
normally one-foot-high figures is to highlight their
already distorted bodies to the point of grotesqueness.
Yet this bizarre quality is what contributes to the work's
impact. By exaggerating *Hiropon*'s freakishness,
Murakami exposes the monstrosity of the fantasy.
It is an indictment and an embrace of *otaku* obses-
sions, and this is exemplified by the work's title.
Hiropon is slang for heroin, thus echoing her addic-
tive potential for *otaku*. The *otaku*'s dream becomes
the nightmare of a powerful woman who revels in
her own, albeit strange, pleasure.

Hiropon has a male counterpart, *My Lonesome
Cowboy*, which Murakami created at the suggestion
of Toshio Okada, the animation film producer.[32]

25 Noi Sawaragi interviewed
by Fumio Nanjo in
"Dangerously Cute," *Flash Art*
25, (March/April 1992): 75.

26 Treat, 281.

27 Murakami, *Index:* 48.

28 Takashi Murakami,
"POP+OTAKU=PO+KU," *Big,*
no. 21 (1999): 44.

29 In conversation with the
artist, February 23, 1999.

30 Ibid.

31 Ibid.

32 In conversation with the
artist, June 24, 1999.

My Lonesome Cowboy is also an overscaled cartoon figure with spiky hair and a *manga* face. He is naked and sports a large erection that spouts a lasso of ejaculate that hovers over him. Images of men as sexual objects are rare in Japan, so Murakami looked to various sources for the figure's attributes. He modeled the face after a character in the popular Sega game Final Fantasy, so that it would be familiar to viewers.[33] The idea for the cowboy character originated in a novel of the same title by Yoshio Kataoka about a truck driver traveling in the United States. In an interview with Paul McCarthy, Murakami asserts that unlike *Hiropon*, *My Lonesome Cowboy* is unrelated to *otaku* culture but is rather "my twisted U.S. image. Thus 'My' [as in *My Lonesome Cowboy*] is my reality about America."[34] Another source was a film by Bob Flanagan in which he hammers his penis with predictably bloody results. The image of the extravagantly endowed man is a common one in Machino's *manga* but also in earlier cartoons.

Frederik Schodt traces erotic *manga* to the erotic woodblock prints called *shunga* produced during the Edo period (1615–1868). *Shunga* artists often depicted men with enormous members and produced scrolls on the theme of "phallic contests."[35] The *ukiyo-e* prints of the same period were a popular form of entertainment (much like *manga* today), full of humor and, sometimes, uninhibited sex. The renowned print artist Katsushika Hokusai (1760–1849) coined the term *manga*, and his own collection of such sketches numbered fifteen volumes that were so popular the blocks wore out from so many printings.[36] Americans know Hokusai for his famous depiction of an immense frothy wave, which has become a pop icon. Speaking of *Hiropon*, Murakami has said, "Like Hokusai's pictures, sex in Japan is stylized."[37]

Murakami has installed *Hiropon* and *My Lonesome Cowboy* with two *Splash* paintings providing the background. The *Splash* paintings belong to a series of abstractions (including *Milk* and *Cream*) that depict dynamic white lines against monochromatic fields. When paired with the two sculptures, the paintings look as if they contain the splashes from the figures' playful activities. Murakami has acknowledged that traditional Japanese painting,

which renders space as shallow, inspires the flatness in these works. The historical reference is so deliberate that Murakami entitled a recent exhibition *Super Flat*. As is typical of Murakami, he updates a historical stylistic trait with his interest in animation, here that of Yoshinori Kanada. Murakami culled the forms of the splashes from Kanada's depictions of flames in his film *Goodbye to Galaxy Railway 999*. Murakami points out that the difference between American and Japanese animation is the two-dimensional style of the latter, which he prefers.[38] The *Splash* paintings have the artfully artificial look of animation while retaining the elegance of traditional Japanese painting. The elegance is a result of what is left out as much as how the works are painted. There is a suggestion of events occurring outside the edges of the paintings, that what has landed on the canvases is only a part of a larger trajectory of fluid.

Writing of the influence of woodblock prints on *anime*, Antonia Levi states that Japan's artistic and theatrical traditions are not realistic but rather suggestive, forcing the viewer to fill in the gaps. She cites the example of woodblock prints, in which a partial image hints at a larger picture, like Hokusai's single powerful wave that implies the enormity of the ocean. Levi argues that *anime*, with its similar effects, is an updating of this tradition.[39] Murakami's interest in flatness extends beyond merely formal concerns. As Tetsuo Shimizu explains the artist's concept of "super flatness," it "refers to the flatness of a mirror that reflects our other self, our alter ego, suffocating from internal contradictions."[40] Murakami considers his work a mirror of the current Japanese reality in all its complexity, but specifically the *otaku* culture. He argues that this once obscure subculture has evolved into a powerful mainstream force that he defines as "PO+KU (pop+otaku)." According to the artist, this phenomenon may finally be Japan's most original cultural product. As he states, "The original American pop culture was born at the height of the American economy, but for Japan, delayed by forty years, the formatting of pop as a context has finally finished and the reconstruction of the culture is just starting."[41] Murakami's art embodies this new cultural force in all its exuberance.

33 In conversation with the artist, February 23, 1999.

34 Takashi Murakami interviewed by Paul McCarthy, *Super Flat*, exhibition poster (New York: Marianne Boesky Gallery, 1999).

35 Frederik L. Schodt, *Manga! Manga! The World of Japanese Comics* (Tokyo and New York: Kodansha International, 1983): 35–36, 131.

36 Ibid., 33–35.

37 Matsui, "Murakami Takashi: Nihilist Agonistes," 51.

38 In conversation with the artist, February 23, 1999.

39 Levi, 21.

40 Tetsuo Shimizu, "KIASMO (Crossing): Considering the Diverse Trends of Contemporary Japanese Art in the Nineties with Reference to Earlier Postwar Developments," in *Tastes and Pursuits: Japanese Art in the 1990s*, exh. cat. (Tokyo: The Japan Foundation, 1998): 20.

41 Murakami, *Big*, 44.

Toward a Definition of
TOKYO POP:
The Classical Transgressions of
Takashi Murakami

Midori Matsui

Takashi Murakami is the most conspicuous member of the generation of new Pop artists who emerged in 1991 and 1992, boldly challenging the sterile formalism of institutionally defined "contemporary art" with shamelessly colorful art objects simulating the visual vocabulary of contemporary Japanese popular culture. Along with Taro Chiezo, Mariko Mori and Kenji Yanobe, Murakami represents both the materialistic attachment and cultural predicament of the generation who grew up in the 1960s and early 1970s amid Japan's industrial and economic expansion, possessing no common language of their identity other than those of subcultures.[1]

fig. 1 Itō Jakuchū, *Hasuike yūgyozu (Fish Swimming in a Pond of Lillies)*, 18th century
Color painting on silk
56 1/8 x 31 1/4 in. (142.4 x 79.3 cm)
Sannomaru Shōzōkan Museum, Imperial Household Agency

fig. 2 Anonymous, *Choju giga (Playful Picture of Birds and Animals)*, 12th century
Ink on screen
4 3/4 x 11 15/16 in. (12 x 30.4 cm)
Kōzanji Temple

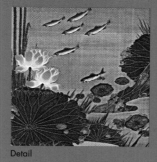

Detail

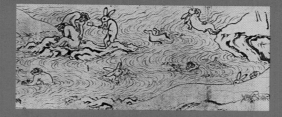

fig. 3 Katsushika Hokusai, *Drawing of Imaginary Animals, Hokusai Manga*, vol.2, 1815
Katsushika Hokusai Museum

fig. 4 Katsushika Hokusai, *Toushisenga shichigonritsu*, vol. 2, 1833
Katsushika Hokusai Museum

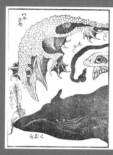
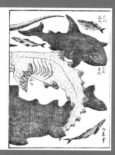

What distinguishes Murakami from his fellow artists, however, is his conscious exposure of the contradiction that many aspects of postwar Japanese culture—including *anime*—are a consequence of Japan's cultural colonization. This critical awareness has been accompanied by his consistent references to the techniques and motifs of traditional Japanese painting. In recent years, these tendencies have converged, with Murakami consciously incorporating in his own paintings splash motifs that evoke the pictorial signatures of traditional painters, frequently juxtaposed with DOB, his original *anime* character. This mirroring of "oriental" aspects has two sides: first, it subtly conceals Murakami's bold attack on the fundamentally Western institution of contemporary art, with his icons of excessive otherness disrupting its typically linear progress; second, the combination of traditional and mass cultural motifs indicates Murakami's genuine desire to reinstate the radical self-reflexivity of Japan's domestic pictorial culture, whose characteristics are shared by the apparently separate practices of premodern Japanese painting and postmodern comic animation. By "domestic" I mean the particularly Japanese way of translating and

naturalizing imported creative codes, because nothing that grows in Japan is purely "native." Everything is a reaction to and a modification of a received foreign culture. For centuries, the major influence was China; since the late nineteenth century it has been the West.

Murakami's artistic and discursive strategies formulate a domestic theory of Pop art, and offer it as an alternative to the stagnant intellectualism of postwar Japanese art. By claiming Japan's domestic pictorial tradition as his heritage, restated as the precursor of the Pop art he seeks to realize, Murakami inevitably exposes the problematic nature of Japanese high culture, which was itself a product of Japan's incomplete modernity. Japan's forced modernization—the swift importation of Western sciences and technology from the late nineteenth century onward—resulted in the distorted development of Japanese high culture that bears little relevance either to the history of Western art or to the reality of current public life. In the same way, the art that developed after 1945 is trapped within inadequately adapted Western techniques and ideas, culminating in the willful neglect of

All translations from the Japanese are by the author.

1 For one of the earliest and most concise accounts of the emergence of new Pop art in Japan see Dana Friis-Hansen, "Japan Today: Empire of Goods, Young Japanese Artists and the Commodity Culture," *Flash Art 25* (March–April 1992): 78–81.

fig. 5 Soga Shōhaku, *A Dragon in the Cloud*, 18th century
Ink on paper
65 3/8 x 105 3/4 in. (166 x 268.5 cm)
William Sturgis Bigelow Collection, Museum of Fine Arts, Boston

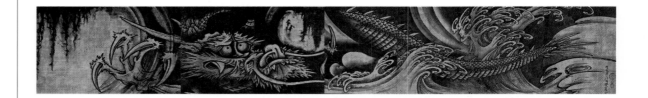

object-making in the name of conceptual art practices. In this false legitimation of high culture, the longstanding pictorial traditions of decorative stylization and distortion of natural detail have been marginalized and rendered insignificant.

Murakami's playful bridging of premodern and postmodern visual practices should not be confused, however, with the dubious late-1980s idea of transcending modernity through a facile analogy of the "language games" of the Edo culture and contemporary advertising and entertainment.[2] In contrast to the formal continuity between the eighteenth-century wall paintings of Kanō Sansetsu, the nineteenth-century *ukiyo-e* prints of Katsushika Hokusai, the eccentric depictions of explosions by contemporary animation master Yoshinori Kanada, and the idiosyncratic lines of cartoonist Taiyo Matsumoto, Murakami's bridging carries a more productive intent. It reveals a spirit of formal innovation that existed in Japanese art prior to and independent of its contact with Western theories of modernity. While Murakami's analogy is informed by the original theories of art historian Nobuo Tsuji, I would add that the signature characteristics of Japanese aesthetics identified by Tsuji (and brilliantly incorporated in Murakami's artwork) bear a fundamental resemblance to the rhetorical characteristics of postmodern representation.

Rediscovering Japanese Visual Play

In his lecture "The Super Flat Is the Spirit of the Japanese,"[3] Murakami presented his definition of Japanese painting against the conventions of nineteenth-century Japanese painting or *nihon-ga*. According to him, *nihon-ga* was a source of national pride for its artists as well as its audience in the late nineteenth century.[4] The invention of the category was purely a consequence of the Meiji Restoration, the national movement of modernization

and enlightenment that followed Japan's blanket acceptance of Western ideas and lifestyles. Before then, neither the idea of art nor *nihon-ga* existed; there were only numerous schools of painting and individual painters that produced the original designs for *ukiyo-e* prints. The category of *yō-ga*, or Western-style painting—with its emphasis on classical proportions, linear perspective, and mythological or historical themes—was established as the official art of this enlightenment. The category of *nihon-ga* was invented in the 1890s by Ernest Fenolosa and Okakura Tenshin partly in protest to the marginalization of traditional Japanese painting and partly as a vehicle for the idea of a pan-Asian cultural continuity, an eclectic adaptation and formal integration of such diverse sources as twelfth-century Chinese painting and the latest experiments of Cézanne or Monet. In 1896 Tenshin initiated *Nihon Kaiga Kyokai*, the association of innovative *nihon-ga* painters, which two years later developed into *Nihon Bijutsu In*, the more ideologically integrated art institution. Tenshin's idealism and encouragement of formal experimentation attracted many talented young painters who participated in the *In-ten*, the annual art competition held by *Nihon Bijutsu In* or *Koku-ten*, *In-ten's* Kyoto counterpart. Producing highly original and aesthetically refined works, the *In-ten* and *Koku-ten* schools of *nihon-ga* artists commanded a broad influence while winning the respect and popularity of the Japanese public, particularly between the 1920s and the beginning of World War II.

The relevance of this Japanese style of painting diminished after the defeat of Japan in World War II and the subsequent repudiation of those intellectuals and artists who took part in the production of war propaganda. In his lecture Murakami attributed the popularity of such postwar *nihon-ga* masters as

2 Karatani Kojin, "One Spirit, Two Nineteenth Centuries," *South Atlantic Quarterly* 87 (Summer 1988): 615–28.

3 Takashi Murakami, "The Super Flat Is the Spirit of the Japanese," lecture delivered at the Mitaka City Center for Art, March 7, 1999.

4 Michiaki Kawakita, *Kindai nihon bijutsu no chōryu* (The Current of Modern Japanese Art) (Tokyo: Kodansha, 1978): 94–96.

fig. 6 Kanō Sansetsu (attributed to), *Robai zu (Old Plum Tree)*, 1647
Colors and gold leaf on paper
Sliding door panels, set of four
68 3/4 x 191 1/8 in. (174.5 x 485.3 cm)
The Metropolitan Museum of Art, The Harry G. C. Packard Collection of Asian Art, Gift of Harry G. C. Packard
and Purchase, Fletcher, Rogers, Harris Brisbane Dick and Louis V. Bell Funds, Joseph Pulitzer Bequest and the
Annenberg Fund, Inc., Gift, 1975 (1975.268.48)

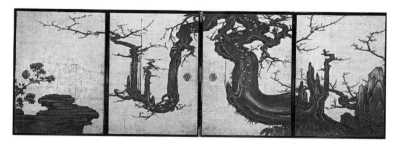

Ikuo Hirayama or Yasushi Sugiyama in the 1960s and 1970s to their willingness to provide imaginary emblems of cultural origin and national identity for the Japanese public, even though this took the kitschy form of presenting the Silk Road or the pyramids as metaphors for Japan's equality with Central Asian and Middle Eastern cultures. Admitting the political importance of *nihon-ga* painting during repeated crises of national identity, Murakami nevertheless emphasized the alienation of the present *nihon-ga* practice from the cultural reality of the Japanese public. Rather than providing a false emblem of Japanese national identity, Murakami himself preferred reviving those features of traditional Japanese painting that uniquely represented the culture's aesthetic imagination. Largely relying on Tsuji's ideas, Murakami explained how traditional Japanese paintings disrupt realistic representation and narrative continuity by exaggerating the idiosyncrasies of individual lines and designs, applying ornamental stylization and playfully distorting the landscape, people and animals to create autonomous spaces within the artistic convention of "copying nature" (fig. 1). Conversely, such visual play trained viewers to look at paintings according to their aesthetic references, which were either self-reflexive or parodies of earlier artistic expressions.

Murakami claimed that this creation of an autonomous aesthetic space within the framework of realistic representation—a parasitic practice that finally overtakes and transforms the body of its host—is the radical spirit of the Japanese two-dimensional aesthetic, or what he calls "Super Flat" art. The significance of this aesthetic is hard to defend against the longstanding authority of realistic representation. Judged by rational standards, formal play is considered devious or at best a whimsical diversion better suited to the applied arts of decoration and design than to the serious art of representation. Tsuji points out that the twelfth-century Chinese aristocrats held this belief, all the while collecting Japanese ornamental dishes and fans. This mimetic bias was precisely the reason traditional Japanese paintings, including *ukiyo-e* prints, were considered inferior to classic Western paintings as vehicles for expressing spirituality and deep emotions during the Meiji Enlightenment.[5]

In his superb introduction to classical Japanese art, *Nihon Bijutsu no mikata* (A Perspective for Japanese Art), Tsuji claims that the natural philosophy of life is expressed by the Japanese love of decoration. To decorate, or *kazaru*, is deeply associated in Japanese culture with celebrating life, warding off the awareness of death and the transience of cherished moments. Decoration is an expression of the Japanese people's unceasing pursuit of joy in life as well as an assertion of individuality through the artful transformation of what is naturally given.[6] As another essential characteristic of the Japanese artistic spirit, Tsuji designates the childlike humor conveyed in the playful, sometimes caricaturesque distortions of human and animal forms that occur in drawings variously called *manga*, *oko-e* (humorous doodles dating from the eleventh century, of which figure 2 is a later example), and *osokuzu no e* (humorous pornographic drawings made in the twelfth century). The word *manga* itself became widely known through Hokusai's *Hokusai manga* (1812–19): caricaturesque or free-style drawings of people, animals, plants, buildings and so on, and illustrations for dramatic narratives for which he invented imaginary creatures radically distorted from the lifelike sketches of fish and animals in imported Dutch encyclopedias and presaging *kaijyū*, the monsters of contemporary sci-fi films and *anime* (figs. 3–5).[7] Tsuji asserts that the playful and bold stylization of nature embodied in *manga*

5 Nobuo Tsuji, *Nihon Bijutsu no mikata* (A Perspective for Japanese Art) (Tokyo: Iwanami Shoten, 1992): 4.

6 Ibid., 24–25.

7 Nobuo Tsuji, *Hokusai* (Tokyo: Shogakukan, 1982):118–24; and *Kisō no zufu* (Curiosity in Japanese Art) (Tokyo: Heibonsha, 1989): 38–43.

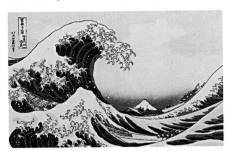 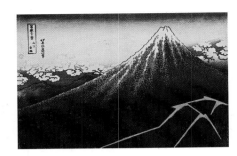

epitomizes the vitality and freedom of the Japanese popular imagination, arguing that even after its marginalization by modern institutions of art, *manga*'s playful spirit survives in postwar Japanese comics and animation.[8]

In the course of his lecture, Murakami evidenced Tsuji's astute theories by showing slides and videos illustrating the amazing formal similarities between Sansetsu's drawing of a gnarled plum branch; Hokusai's depictions of lightning over a red Mt. Fuji and the dynamic splash of ocean waves; Kanada's animation sequences of an explosive fireball spreading like the tentacles of an extraterrestrial monster; and Matsumoto's drawing of a ping-pong player's hand protruding like an enormous tidal wave (figs. 6–10). Murakami's admiration for this radically decorative heritage is potently expressed in his recent *Splash* paintings and the sculptural piece *My Lonesome Cowboy* (pls. 36–38). The latter is a life-sized figure of a stylishly swaggering *anime* man with a cosmic splash of his spurting semen spreading out above his head like a milky lasso. Decorative bliss, hypernatural transformation and childlike playfulness are superbly demonstrated in this work, as if in response to Tsuji's passionate plea for a return of the repressed:

> Japanese art originally made no clear distinction between painting and craft. Japanese craft, by nature ambiguous, includes the merits of both pictorial representation and ornamental stylization, recreating the vitality of life in a way no realistic representation could. This achievement of highly artistic expression between the categories of painting and craft is perhaps the major characteristic of Japanese art....Nevertheless, the intimate relationship between painting and craft was repressed in art history after the Western idea

of fine art was imported by the Meiji Restoration. Unfortunately, the "passion to decorate" unique to the Japanese mind seems to have lost its vitality, having no legitimate place in which to assert its power. But today, the idea of pure art that looks down on decorative design has also become a history. I truly hope that decoration will liberate itself from the curse of "pure art" and regain its innate ability to assert both realms in singular works of art.[9]

Besides its decorative brilliance, *My Lonesome Cowboy* achieves Murakami's experimental goals on several other levels. First, it successfully transfers the fantastic facial and bodily proportions of Japanese comics to the three-dimensional "garage kit" format, an elaborate sculptural version of *anime* characters invented in the 1980s by *otaku* craftsmen. Thus its radical deformity realizes his idea of the "Super Flat" by creating a resplendent, totally fictitious physical reality. The figure's humor and nonchalant sexual exhibitionism capture the two fundamental characteristics of the original *manga*: the humor of *oko e* and the uninhibited sexuality of *osokuzu no e*, just as they were creatively integrated in Sotatsu's seventeenth-century masterpiece *Fujin* (*The God of Wind*, fig. 11). By presenting a hybrid of premodern and postmodern figurative excesses, Murakami revives the domestic sensibility previously repressed by modern Japanese high culture in favor of spiritual depth.

From the "Bad Place" to Tokyo Pop

Noi Sawaragi is an art critic who has consistently and polemically defended the practices of Murakami and his peers since their emergence in the early 1990s.[10] In his recent book, *Nihon, gendai, bijutsu* (Japanese Contemporary Art), he dismisses the practices of the postwar Japanese

8 Tsuji, *Nihon Bijutsu no mikata*, 93.

9 Ibid., 47.

10 Noi Sawaragi, "Dangerously Cute: A Talk with Fumio Nanjo," *Flash Art* 25 (March–April, 1992): 77–79; and Sawaragi, "Roti-poppu—sono kyokushouno inochino katachi" (Lolli-Pop: The Smallest Possible Form of Life), *Bijutsu Techo* 44 (March 1992): 86–92.

avant-garde for its failure either to realize modern rationality or to construct a unique conceptual system that was responsive to the reality of contemporary life. Sawaragi's polemic is in part intended to refute the theoretical ground of Shigeo Chiba's influential book, *Gendai bijutsu itsudatsu shi* (The History of Japanese Contemporary Art as Deviation). Chiba argues that the postwar Japanese avant-garde established its identity by deliberately abandoning the creation of finished objects, refusing to be judged by the standards of material autonomy. Avant-garde artists placed more value in live action, like the *Gutai* group in the 1950s, or in making their nonproduction a statement about the dead end of formal experimentation, as in the antiart demonstrations of *Bikyōto* (Art Revolution) in the 1970s.[11]

Sawaragi opposes Chiba's thesis by arguing that the fundamentally emotional motivation of the postwar antiart activities merely confirmed the irrelevance of Japanese avant-gardism to the history of contemporary art in the West. Sawaragi further contended that Japanese contemporary art had no "history," since, confined as they were to their narrow circles and scarcely speaking to other generations and groups, avant-garde artists became stagnant, repeating the same old errors in new fashions and rhetorics. Even Chiba's assumption that *Bikyoto* marked a turning point in postwar art history by placing conceptual practices before the production of tangible art objects was interpreted by Sawaragi as the closure of Japanese contemporary art, since, by abandoning the production of physical objects, the avant-garde had relinquished their chance to leave a trace of their historical reality.[12]

> This "turning point" that Chiba compared to a Copernican revolution does not mark a historical turning point at all; rather, it suggests the continuing influence of an ahistorical "place" in which art is forced to remain. I would even assert that this ahistorical place is none other than the "closed circuit" of Japanese contemporary art: the limbo of circular thinking that gives a false appearance of unity to the divided historical body of contemporary art in Japan.[13]

Regarding the period from 1955 to 1989, Sawaragi writes:

> The Japanese avant-garde has nothing to do with the intellectual impetus of the Western avant-garde, whose resistance to modern institutions is carried out by a strong individualism and a rationality rooted in the same modern solipsisms. The Japanese avant-garde has been driven by the sadness of those who have inherited superficial and incomplete institutions of modernity, destructive energies without direction, anarchism motivated by despair and an insecure intellect seeking solace in the rhetorical resolution of an ironic Japanese a-history.[14]

Sawaragi goes on to say that every form of art produced during this period is nothing but empty kitsch compared with the contemporaneous artworks of the West. He considers it the sad fate of a Japanese artist to have to begin his or her career in this "bad place"—the field of Japanese contemporary art that does not possess a legitimate institution, let alone adequate systems of appreciation, evaluation, exhibition and economic distribution. Nonetheless, making his own Copernican revolution, Sawaragi turns this "weakness" into a springboard for reflecting on the reasons for Japanese artists to make art: "We do not need to set out impatiently on our way beyond the closed circuit of Japanese contemporary art, but to acknowledge this closure and reflect on the way it has undeniably conditioned our lives."[15]

11 Shigeo Chiba, *Gendai bijutsu itsudatsu shi* (The History of Japanese Contemporary Art as Deviation) (Tokyo: Shobunsha, 1986, 1997): 81–82.

12 Noi Sawaragi, *Nihon, gendai, bijutsu* (Japanese Contemporary Art) (Tokyo: Shinchosha, 1998): 11.

13 Ibid., 14.

14 Ibid., 30.

15 Ibid., 23.

pl. 37 Takashi Murakami, *Cream*, 1998
Acrylic on linen on board
92 x 192 in. (233 x 487 cm)
Collection of Eileen and Peter Norton, Santa Monica

pl. 38 Takashi Murakami, *My Lonesome Cowboy*, 1998
Oil, acrylic, fiberglass and iron
100 x 46 x 36 in. (254 x 116.8 x 91 cm)
Fractional and Promised Gift of Vicki and Kent A. Logan to
the collection of the San Francisco Museum of Modern Art
Edition 2/3

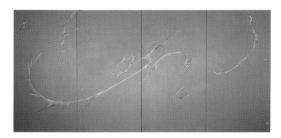

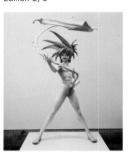

16 Ibid., 52.

17 Noi Sawaragi, "Tokyo poppu towa nani ka" (What Is "Tokyo Pop"?), *Kōkoku hihyō* 226 (April 1999): 70–78.

18 Ibid., 77–78.

19 Ibid., 78.

20 Takashi Murakami and Yasumasa Morimura, "Art to ato no aidade nihon no bijutsu wa yurete iru" (Japanese Contemporary Art Fluctuates between Western and Japanese Ideas), *Kōkoku hihyō* 226 (April 1999): 86–102.

Sawaragi sees in the emergence of the new Pop art in the early 1990s the first authentic opportunity to break open the closure of Japanese contemporary art. He argues that the absurd look of the new Pop directly reflects the anarchic influence of postwar Japanese mass culture, whose lack of criteria allowed disruptive excesses to develop. Absorbing the vulgar energy of mass culture while possessing cool irony, the new Pop marks a clear break with the previous practices of Japanese contemporary art. Moreover, the new Pop, or what Sawaragi now called the "Reductive Pop," was motivated by a dark awareness of their historical insignificance, as its deliberately kitsch appearance flaunted ignoble ties with such despicable materials as *manga*, animation films, monsters in cheap sci-fi TV movies, video games—in short, the objects of the dubious *otaku* or geek connoisseurship. Sawaragi argues that the American origin of these expressions relentlessly exposed the colonial origin of the new Pop imagination. Murakami and others were to be commended for bravely confronting their historical shame and expressing themselves in crisis—split between the West and Japan, fine art and subculture—with sarcastic humor. The frequently clownish displays of their ambiguous cultural identity paradoxically suggest their sincerity. Their purpose is "not to invent a new system of values on which they can depend, but to keep discovering the meaning of their lives through their differences from such systems."[16]

If Sawaragi's explanation of the new Pop sounds too strictly determined by his own philosophy of postmodern nihilism, in his more recent essay, "What is 'Tokyo Pop'?" he gives a more hopeful account of Murakami's strategy by drawing an analogy between the current situation of artists in Tokyo and London's Pop artists of the 1960s. The fear and admiration of American capitalist culture led the Londoners to critical reflections that indirectly propelled the development of a domestic Pop culture—although the hybrid performances of British "art rock" were more successful than the visual output of British Pop artists. Sawaragi argues that the chaotic flourishing of subculture in Tokyo today provides an opportunity for deregulating the academic categories of contemporary art, whose wealth he proposes to call "Tokyo Pop" after the example of Lawrence Alloway.[17] Among contemporary subcultural themes, Sawaragi specifically focuses on the pornographic expressions in *otaku* media, and the grotesque three-dimensional formations of *kaijū*, imaginary monsters like Godzilla, as the most potent vehicles for the notion of Tokyo Pop. They provide the keys to reintegrating what has been marginalized in modern Japanese culture. While the uninhibited expression of sexuality has been repressed by official high culture since the Meiji Restoration, the prototype of *kaijū* was made by two men trained in painting and sculpture who applied high art techniques to the bastard art of creating monsters for children's films.[18] Sawaragi argues that the hybrid products of contemporary Japanese pop culture—including the self-reflexive animation film *Neon Genesis Evangelion*—are artistic mutants that do not fit categories of contemporary art; born out of the Japanese imitation of American Pop culture, they surpass the originals in their flexible intermingling of high and low information.[19]

Murakami himself clearly states that Japanese art history is intellectually vacuous and instead grounds his artistic production in the chaos of contemporary Tokyo. Fully aware of the precarious position of Japanese art in an international context, where it inevitably remains an "other," Murakami offers his artwork as evidence of how the negative consciousness of cultural colonialism can be transformed into strangely beautiful anomalies[20]:

fig. 11 Tawaraya Sotatsu, *Fujin raijin zu byobu* (The God of Wind), part of folding screen painting *The Gods of Wind and Thunder,* 17th century
Color painting on folding screen
60 13/16 x 66 7/8 (154.5 x 169.8 cm)
Kenninji Temple

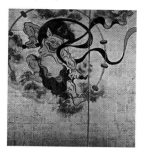

fig. 12 Bome, Model of a girl (based on original design by Misato Mitsumi), 1999
Oil and resin

Yasumasa Morimura deliberately exploits Western images of otherness in order to express his historical predicament, while Tatsuo Miyajima invented an LED numbering system that excludes the number zero, suggesting that the ambiguity of the East cannot be worked out through the distinction between zero and one. Both artists succeed because they critically expose the relationships between Western and Eastern culture. The problem for my generation is to create original products without depending on an intellectual system for support, since we are aware of differences between the workings of contemporary art in the West and how things operate in Japan. I first thought that it was impossible to create anything under such circumstances. Nonetheless, I decided to express the uncertainty of creating artwork in Japan by working on the paradox of making artwork itself, knowing that there's no system for properly evaluating it. That is why my work references Japanese animation culture, which itself began as an imitation of imported American animation.[21]

Murakami's alchemical effort to turn the "debased" products of *otaku* culture into artworks also takes the form of curatorial projects. Such exhibitions as *Ero Pop Tokyo* (1998), *Hiropon Show* and *Tokyo Girls Bravo!* (both 1999) presented the works of his studio assistants alongside those of professional makers of *otaku* gadgets, merging the boundaries of art and subculture in contemporary Tokyo. Murakami's tapping of the resources of *otaku* culture is consistent with his efforts to revive the traditions of playfulness and connoisseurship that existed in Edo popular culture, which operated strictly in the unacademic but hermetic language of craft. *Otaku* is the contemporary counterpart of the *Edo tsū*, the well-versed amateur, having emerged in the early 1980s as a generation of pop culture enthusiasts equipped with detailed knowledge of comics, animation films, garage kits and other underground obsessions. Formerly marginalized as a negative embodiment of Japanese postconsumer materialism and infantilism, *otaku* is now hailed as a prototype of new cultural connoisseurship.[22] By frequently including in his exhibitions the erotic *anime*-based sculptures of the master craftsman of garage kits, Bome, and the humorously pornographic drawings of underground comic personality Henmaru Machino, Murakami celebrates the vitality of the Edo *manga* through the time warp of contemporary Tokyo's most forbidden pop culture (figs. 12, 13).

Metonymic Chains and Schizophrenic Visions—Decoration and Postmodernism in Murakami's Work

Having looked at Murakami's work in the context of Japanese art, I want to address the similarities between Murakami's formal technique and the rhetorical idiosyncrasies of postmodern representation that have occurred internationally. My application of postmodern categories, however, is distinguished from the generally accepted view of postmodern art as a simulationist subversion of modern codes of representation as exemplified in the works of Cindy Sherman or Sherry Levine; nor does my definition have anything in common with the popular view that regards postmodern representation as a clever exploitation of camp, kitsch, or parody.[23] Eccentric as it may seem, I prefer to apply the rhetorical characteristics of postmodern narrative and poetry, namely metonymic chains of association that disrupt rational order and the schizophrenic juxtaposition of fragments that collapses time and draws one's attention to the materiality of signs. There is a fundamental affinity between these strategies and Murakami's conjuring of alternate dimensions of reality, unfettered by the mimetic demands of rational space or logic.

21 Ibid., 88.

22 Toshio Okada, *Otakugaku nyumon* (Introduction to the Study of Otaku) (Tokyo: Ota Shuppan, 1996): 85.

23 For a thorough analysis of Simulationist art see Craig Owens, *Beyond Recognition* (Berkeley: University of California Press, 1992), and Nigel Weale, ed., *Postmodern Arts* (New York: Routledge, 1995): 48–51.

24 Fredric Jameson, "Postmodernism and Consumer Society," in Hal Foster, ed., *The Anti-Aesthetic* (Port Townsend, Wash.: Bay Press, 1983): 118–23.

25 Julia Kristeva, "From Symbol to Sign," in Toril Moi, ed., *The Kristeva Reader* (New York: Columbia University Press, 1986): 70. For a discussion of metonymic displacement as a predominant characteristic of postmodern literary texts, see Christine Brooke-Rose, *A Rhetoric of the Unreal* (New York: Cambridge University Press, 1981): 23–24, 354–63.

26 Nobuo Tsuji, *Nihon Bijutsu no mikata*, 32.

The schizophrenic disruption of rational space can be seen in Murakami's *The Castle of Tin Tin* (1998, pl. 39), which portrays DOB as a towering spiral, its protrusions bearing faces with bulging eyes and mouths, some of which emit colorful bubbles. The apparent relation between the center and the periphery, the whole and its parts, however, is betrayed by the way the eye is led from one brightly colored dot to another. This visual experience of the pictorial space, totally different from anything produced by linear perspective, is attained by the flat and unhierarchical application of paint to every detail, a variation on the ornamental technique of classical Japanese painting. At the same time, bright spots of paint individually assert themselves and create a subtle, optical push and pull similar to the flat rhetorical poems of the Language Poets, an experimental poetry group that emerged in the U.S. in the early 1980s known for juxtaposing specific images without providing any narrative continuity, thereby creating hallucinatory effects through the intense materialization of these fragments.[24]

The other characteristic of postmodern technique, what Julia Kristeva calls a "metonymic chain of deflections," creates a heterogeneous sense of play within a given discourse, constantly exacerbating its logical construction and transforming its concrete symbols into arbitrary signs.[25] Surprisingly, similar flights of fancy can be observed in the inlaid pattern of a twelfth-century Japanese letter box, in which an incidental detail in the Buddhist text is extracted and transformed into a luxurious pattern, held between its symbolic meaning and its own material splendor. Taking advantage of the formal constraints of decorative design, the artist of the inlaid box emphasized the uniquely symbolic and plastic effects of formal patterns: a stylized pattern describes a view of carriage wheels in the Kamo River, which in turn refers to the Buddhist expression that compares a large, beautiful lily blossom to a wheel. In short, the inlaid pattern of the letter box functions as a rebus, a witty metonym reflecting the double vision of a twelfth-century aristocrat who sees the particular phenomena of this world as a direct embodiment of the events in Buddhist heaven. By incorporating a symbolic function in its surface decoration, the box also signifies the spiritual life of the people who used it. Many patterns in Japanese decoration contain symbolic meanings related to religious belief, a prayer for happiness or a charm against bad luck. Even in these cases, however, a design is never totally reduced to a symbol; cleverness and visual pleasure take precedence over meaning. This technique of effecting visual play through a metonymic chain of fragmented images continues in the design of *mitate*, the metonymic insertion of details from classic tales and scenes in seventeenth- and eighteenth-century Japanese design.[26]

A similar substitution of parts for the whole is seen in Murakami's *A Very Merry Unbirthday!* (1993, fig. 14), an enormous metallic globe consisting of 36,525 light bulbs. With the bulbs corresponding to the number of days in one hundred years, the work embodies the paradox of an accumulation of apparently insignificant details being able to evoke a sense of wonder or even bliss. Referring to the remark of the Mad Hatter in *Alice in Wonderland*, the gratuitous yet elegant cultivation of nonsense in *A Very Merry Unbirthday!* is also the theme of Murakami's dissertation, "The Meaning of Non-meaning." There is little in common between Lewis Carroll's text and the absurd appearance of Murakami's sculpture; nonetheless, the sphere's golden glitter captures our puzzling fascination with the chimerical "nothing" called art. Like the design of the wheel in water, it is a beautiful rebus suspended between meaning and nonmeaning.

fig. 14 Takashi Murakami, *A Very Merry Unbirthday!*, 1993
Iron, decorative bulbs and computer
59 in. diameter

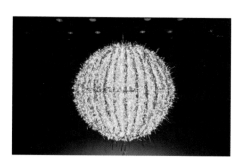

fig. 15 Itō Jakuchū, *Rōshōhakuhōzu (A Phoenix in the Old Pine Tree)*,
18th century
Color on silk
56 1/4 x 31 in. (142.5 x 78.8 cm)
Sannomaru Shōzōkan Museum, Imperial Household Agency

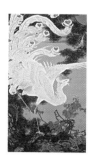 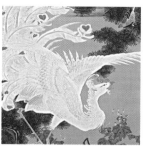

Detail

The conceptual use of ornament in such an early piece confirms Murakami's indebtedness to the traditional Japanese merging of art and craft, making the apparently empty, decorative surface of the art object a concise vehicle of spirituality.

Conclusion

From a critical point of view, Murakami's current conceptual significance is rooted in his conscious appropriation of the products of Japanese subculture as a hybrid offshoot of illegitimate Pop art, born out of the contradictions of the postwar "colonization" of Japanese culture. As Sawaragi maintains, Murakami's assimilation of the erotic and grotesque aspects of Tokyo's popular underground evidences his sincere grappling with the unique historical position of being a Japanese artist in late-capitalist Tokyo without a system of cultural legitimation. Although I am aware that this view is largely shared by Murakami, I disagree with Sawaragi's confrontational definition of Tokyo Pop as a reaction to American pop culture. Murakami's work derives much of its visual pleasure from the playfulness and decorativeness of native Japanese culture. The latter characteristic in particular plays a crucial role in enabling the serene aura of self-containment that surrounds Murakami's work.

Tsuji's explanation of the two contrasting expressions of Japanese Pop, or the eccentric assertion of visual originality that he calls *kisō*, reconciles Sawaragi's and my own emphasis on the different aspects of Murakami's Pop practice. In his study of the Japanese artists of the seventeenth to the nineteenth centuries who embodied this heritage of Pop, *Kisō no keifu* (The Heritage of Eccentric Imagination), Tsuji points out the negative and positive functions of *kisō*: the negative function gave rise to eccentric, grotesque, violent and pornographic images that functioned as expres-

sions of the Edo artists' ironic self-consciousness, their deviations from classical beauty embodying the scars of the artist's conflict with his time—the birth of modernity called *kinsei*.[27] The positive function produced playful, popular expressions including parody and ingenuous artifice, whose metonymic references to classical pictures and texts relieved the monotony of everyday routines.[28] Just as the positive and negative tendencies of *kisō* constitute a uniquely Japanese artistic sensibility, the dialectical relationship of Murakami's critical and formal motifs helps shape Tsuji's idea of Tokyo Pop as a complex response to these two aspects of modernity that he inherits.

In Murakami's "Hello, You Are Alive: Manifesto for Tokyo Pop," which was the highlight of the April 1999 issue of *Kōkoku hihyō* (Criticism of Advertisement) and which he employed as a battleground for his campaign, he proposed using the three negative traits of contemporary Japanese culture—infantile sensibility, the repression of class differences and amateurism—as a springboard for creating a new species of beauty (fig. 15), thus indicating his successful evolution from the resentment of American pop culture to the affirmation of contemporary Japanese reality.[29] With his idea of Tokyo Pop centered on the paradox of an "immature" culture producing marvelous gadgets and evocative visual expressions, Murakami also attempts to reverse the negative perception of Japanese popular culture as "childish" or "insignificant." The definition of Tokyo Pop is fundamentally related to his struggle to find a language for his identity, both as an artist and as an individual. Paradoxically, Murakami's artistic maturation will depend on his ability to sharpen his aesthetic of "immaturity," to reconcile the grace of Japanese tradition with the traumas of modernization.

27 Nobuo Tsuji, *Kisō no keifu* (The Heritage of Eccentric Imagination) (Tokyo: Pelicansha, 1988): 141–43.

28 Ibid., 142.

29 Takashi Murakami, "Haikei kimi wa ikite iru —Tokyo poppu sengen" (Hello, You Are Alive: Manifesto for Tokyo Pop), *Kōkoku hihyō* (April 1999): 58–59.

The Meaning of Murakami's NONSENSE: About "Japan" Itself

Dana Friis-Hansen

Takashi Murakami's diverse art objects and activities tickle the eye and imagination, and his elaborate ideas inspire new ways to think about Japanese culture. Still, his work has frustrated many an observer, Japanese and foreigner alike. The subtitle of this exhibition, *The Meaning of the Nonsense of the Meaning*, might provoke Americans to sigh and think, "the inscrutable Japanese," a stereotype prompted by the fact that the artist hails from a country that is geographically and culturally half a world away. But the challenges and pleasures of Murakami's work stem first from the artist himself and the complications he sets up for us, especially in how he views Japanese-ness from the inside.

pl. 2 Takashi Murakami, *Polyrhythm*, 1991
Synthetic resin, iron and plastic Tamiya 1/35 scale
U.S. Infantry models (West European Theater)
88 x 31 x 14 1/8 in. (234 x 36 x 12.5 cm)
Collection of Tsutomu Ikeuchi, Tokyo

fig. 1 Takashi Murakami, *S.M.B.*, 1991
Toy soldiers and melted butter
Dimensions variable
Collection of the artist

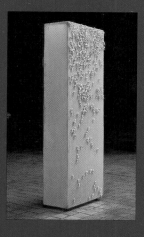

In a decade of artistic production, Murakami has ricocheted like a pachinko ball from traditional Japanese *nihon-ga* painting to quasi-minimalist sculpture to performance events to conceptual, interventionary gestures into mass-media entertainment to cartoony paintings and giant inflatable balloons to factory-fabricated toys, t-shirts, watches and other products to larger-than-life action figures. He mixes, merges and morphs on canvas, lightboxes, posters and large sculptures, cutting a wide, seemingly schizophrenic path that attracts the attention of the international artworld, the Japanese news media, schoolgirls, and the *otaku* or "geek" subculture alike. Murakami has nonetheless become one of the most thoughtful—and thought-provoking—Japanese artists of the 1990s by building a rich body of work that both reflects upon and slyly interrogates postwar, postrecovery Japanese art and popular culture, voraciously absorbing and engaging both history and culture from Japan and the West, from exalted ceremonies to obscure youthful diversions.

On the surface (and the Japanese put great emphasis on appearances) Murakami's high jinks—especially the recent works based on comic books and animated television characters—don't look like other art with complex contemporary content. In 1995 Murakami stated quite clearly that he sought to make art that addresses the unique constructs of cultural and individual identity in Japan, or as he wrote, "about 'Japan' itself."[1] By separating the name of his nation in quotes, he revealed the sophistication of his thinking, acknowledging that he was working with a *construct*, not an *essence* of nation and nationality. And yet recently he declared, "I wanted to make emptiness into sculpture,"[2] undermining the impression of Murakami as an artist committed to the social and political issues of identity. One is certainly left to wonder whether the high stakes of his recent large-scale projects, along with their increasing visibility in the popular media, might not have distracted him from his earlier, more serious cultural concerns. Only days before the opening of the survey exhibition at Bard College he commented, "Now my concept is more pure: I make what I like to make. Right now the young female audience is the hardest to attract, and the challenge of my newest work is to get popular with that group."[3]

1 Takashi Murakami, "Kase Taishuu Project," *Marco Polo* (February 1994). English translation by A. A. Gerow, provided by the artist.

2 Telephone conversation with the artist, June 22, 1999.

3 Ibid.

fig. 2 Takashi Murakami, *Randoseru Project* (detail, installation view and Shinto ceremony event), 1991
Children's backpacks in various animal skins (Cobra skin, seal skin, whale skin, ostrich skin, caiman skin, hippopotamus skin and shark skin)
12 x 9 x 8 in. (30 x 23 x 20 cm) each
Collection of Gallery Cellar, Nagoya, Japan; courtesy of the artist and Shiraishi Contemporary Art, Inc., Tokyo

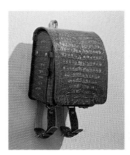

With Murakami's contradictory statements, ambiguous gestures and coy cuteness providing cover, the subversive shenanigans of Marcel Duchamp are brought to mind: his simply but slyly altered readymades, the multifaceted, mythologized "characters" he brought to life over the course of his career, and the feigned forsaking of artmaking for chess (while still regularly producing both major and minor artworks). Art critic Midori Matsui has also observed this parallel, noting that "Murakami shares Duchamp's passion to deconstruct institutional authority through the use of the conceptual [but] only to a limited extent."[4] She warns us, "Let there be no misunderstanding about the 'nonsensical' character of Murakami's artwork. It does not signify a failure to attain meaning."[5] Murakami "attains meaning" by slyly embedding pointed social and political content into refreshingly unconventional art objects, graphic images and public projects. Contradictory assertions about nonsense aside, Murakami shines light on key issues of Japanese culture at the end of the century, specifically childhood innocence and adult responsibility, Japanese culture and Americanization, and individuality and society.

Childhood Innocence and Adult Responsibility

Literally and metaphorically, children play a significant role in Japanese culture. Since World War II a high rate of childbirth has been officially encouraged, mothers are expected to devote their complete attention to raising children, and until it is time to compete for school placement exams in junior high school, young Japanese are coddled and provided with every sort of diversion. In fact one of Murakami's contemporaries, Kohdai Nakahara, reveals how significant these childhood pastimes are when he stresses that Japan's generations are broken up into two- to three-year spans determined by which diversions—Legos, plastic models or computer games, for example—were popular when they were young.[6]

Murakami is part of the 1990s generation of artists who enjoyed the fruits of Japan's postwar recovery and its emergence as an industrial superpower. Unlike their grandparents, who suffered through the war and built the base for reconstruction, and parents, who pulled Japan into its commercial leadership position, this generation of artists born in the 1960s grew up with the time, money and access to such phenomena of popular culture as mass-produced toys and comic books (*manga*), movies and television, pop music and Disneyland. In his youth Murakami developed a special fondness for American culture, in part because his father worked at a U.S. naval base that provided access to information and goods, and through American rock 'n' roll (heard on the U.S. Armed Forces Radio Network). Since his teenage years in the late 1970s a richer and even more pervasive youth culture industry has developed, encompassing an expanded *manga* publication system, *anime* cartoons and films, and a full range of electronic toys and computer games. Murakami works with the key elements of his own childhood as well as those of today's youth culture, transforming seemingly harmless children's objects and imagery into a quiet indictment of particularly sensitive issues of adult responsibility.

Although he was still training as a *nihon-ga* painter, between 1989 and 1991 Murakami planned and produced his first mature contemporary sculptures incorporating readymade materials culled from his youth. In the *Polyrhythm* series (pl. 2), he affixed plastic 1/35th scale (about two inches) American model soldiers manufactured by the famous Japanese model producer Tamiya to

4 Midori Matsui, "Murakami Takashi: Nihilist Agonistes," in *Takashi Murakami: Which Is Tomorrow?—Fall in Love* (Tokyo: SCAI The Bathhouse, 1994): 37.

5 Ibid.

6 Kohdai Nakahara, unpublished statement, "Kohdai Nakahara's message to Dana Friis-Hansen," 1991. English translation provided by Satani Gallery, Tokyo.

pl. 4 Takashi Murakami, *Dobozite Dobozite Oshamanbe*, 1993
Light box
10 1/2 x 30 x 8 in. (26.5 x 76 x 20 cm)
Courtesy of Gallery Cellar, Nagoya, Japan

fig. 3 Takashi Murakami, *Wildoll*, 1991
Vinyl
8 x 7 x 5 in. (20.7 x 17.5 x 12 cm)
Courtesy of the artist

takashi murakami **I 33**

fiberglass forms. Certainly an ironic plaything for the children of World War II survivors, this favored toy becomes a double-edged sword with the opposing readings that the miniaturized infantrymen carry. Are they harmless toys used nostalgically or a sneering, bitter reminder of Japan's militaristic expansionism and its tragic defeat? The country has for decades been engaged in a factional debate (inflamed in the 1990s by the Gulf War and Korean border conflicts) about its own postwar army, the so-called Self-Defense Force, limited by the terms of their World War II surrender and the country's will, clearly stated in Article 9 of its constitution, to "forever renounce war."[7] Murakami softens the prospect of confrontation by mounting them on translucent forms that glow faintly, providing a muted and formalized experience that threatens to transform the soldiers into painterly marks rather than instruments of invasion, thus leaving the viewer an aesthetic escape hatch from a potentially inflammatory political interpretation.

Another key (but temporary) work enlisting the plastic model soldiers is *S.M.B.* (1991, fig. 1), in which a circle of soldiers face outward ready to charge while surrounding a splashy puddle of melted butter. With its circular form and implied rays of outward movement, the arrangement recalls Japan's wartime "rising sun" *Hinomaru* flag (a motif exploited by fellow artist Yukinori Yanagi in his active critique of Japan's militarism[8]). The spilled butter suggests the slippery politics of war and the fallacy of Japan's peacekeeping force, but also recalls the quintessential economic question of whether leaders should favor guns or butter, defense or nourishment. The work's abbreviated title alludes to the children's story *Little Black Sambo*, in which menacing tigers ran in circles so fast that they spun themselves into butter. During the previous decade the storybook had been with-

drawn from circulation—with great publicity—because of pressure from an antiracist faction based in Osaka. This city is known for aggressive action against any discrimination because of its concentration of *Burakumin*, a lower caste of leatherworkers, butchers and menial laborers shunned by mainstream society for their low social status during the Edo period (1615–1868). Although their offspring still remain somewhat segregated today, they are a politically powerful group in social matters concerning discrimination.

1991 was also the year Murakami made his first work with imagery from Japan's rich world of cartoon characters. A five-panel series (pl.1) was based on appropriated cartoon imagery from "Bakabon" (literally, "Stupid One"), a popular 1970s animated television show featuring a bumbling father, an equally daffy son, a hapless baby and a tireless mother who rescued them all from disaster with each installment. One might compare the show to "The Simpsons," in which the head of the household's abdication of responsibility becomes the butt of many jokes. Murakami's exhibition title, *Sansei no Hantai na no da*, loosely translated as "It's that I am against acceptance of it," was a slogan used commonly in the 1970s in student demonstrations against American military bases in Japan and the government's harassment of the Communist party, and one that was declared humorously by the "Bakabon" papa himself. Grammatically, this double negative is a softer way of expressing disagreement (something not easily done in Japan), but it also signals how responsibility works (or doesn't).

Another key work is the *Randoseru Project* (1991, fig. 2), a set of *randoseru*, or children's leather backpacks produced under the artist's direction. Murakami traces the form of this ubiquitous grade-

7 The Japanese Constitution is based on a document prepared by General Douglas MacArthur, Supreme Commander of the Allied Powers, and the American staff of the Occupation Headquarters. The shifts in meaning between the American draft, the ratified Japanese version, and its English translation are revealing and provocative. For more information see Kyoko Inoue, *MacArthur's Japanese Constitution: A Linguistic and Cultural Study of Its Making* (Chicago and London: The University of Chicago Press, 1991).

8 Yukinori Yanagi has created a range of important work about Japan's militarism; for more information see Jane Farver, *Yukinori Yanagi: Project Article 9* (Osaka and New York: Kirin Plaza Osaka and The Queens Museum, 1995).

pl. 7 Takashi Murakami, *Fall in Love*, 1995
Light box
21 3/4 diam. x 4 3/4 in. (55 x 12 cm)
Courtesy of the artist, Tomio Koyama Gallery, Tokyo,
and Blum & Poe, Santa Monica

pl. 17 Takashi Murakami, *And then and then and then and then and then*, 1996–97
Acrylic on canvas on board
110 1/4 x 118 1/8 in. (280 x 300 cm)
Private Collection, Los Angeles; courtesy of Blum & Poe, Santa Monica

school uniform accessory to Meiji-Era military design, and links it to the lingering symbolism of the Imperial system and militarism in the national education program.[9] He also alludes to the historic discrimination against *Burakumin* leatherworkers. One set of eight backpacks replicates the simple design in exotic animal skins including caiman, cobra, ostrich, hippopotamus and whale, a gesture that also connects these conceptual artworks to the elegant luxury leather goods marketed to those with increasing disposable income (that is, before Japan's economic bubble burst). Murakami touches another nerve—the less-than-ideal environmental record of Japan—in his choice of skins off the backs of several species facing extinction. Japan had been criticized globally for ignoring international environmental efforts and was late in ratifying the Washington Convention of International Trade in Endangered Species (CITES), which limited international export of such skins. Nonetheless, they are available for Japanese consumption. This issue of contradiction and diverted ethical responsibility is spelled out in the tag from the Japan Reptile Skins and Leathers Association, which assures the buyer that although the trade in skins of such species is forbidden by international laws, the leather for the bag was imported (probably before the agreement was signed by Japan) "in compliance with Japanese regulations." The unfortunate absence of the *Randoseru Project* from the present exhibition, due to the fact that their importation across national borders is blocked today by Japan's compliance, is an ironic repercussion of the artist's exploration of moral accountability. In a 1991 conversation Murakami recognized the powerful metaphor he created when he observed that although the *randoseru* remind us of the cuteness of schoolchildren, he was "putting some of the world's greatest problems on the backs of Japan's children."[10]

Another way in which the innocence of childhood is made widely visible today is the pervasive marketing of *kawaii*, or "cuteness." This national campaign for a warm, soft, friendly quality with immediate appeal, especially to children and females of all ages, can sometimes feel like an escapist, infantilized and anti-intellectual cloud has been cast over the country. Nevertheless, a design program of "lite happiness" is perhaps needed now more than ever to provide important optimism in the wake of continuing bad news. In a Japan Foundation catalogue surveying the art of the current decade, curator Masanobu Ito sets up a context by chronicling some of the distressing details of 1990s Japan:

> The nineties in Japan began with the bursting of the economic bubble, leaving people with a never-before-experienced feeling of bewilderment, powerlessness, and frustration. Then came the Great Hanshin Earthquake and the release of poison gas in the Tokyo Subway by the AUM Truth Sect. Occurring just 50 years after the end of World War II, these symbolic events shattered the myth of Japan as a completely safe place. There was a whole series of events that were too serious and ominous to dismiss lightly as end-of-the-century phenomena—convulsions in the financial system with failures of major banks and securities companies; a long, dreary recession; corruption in political, administrative, and financial circles; the problem of U.S. bases in Okinawa that led to conflict between the prefecture and the national government; reports of shocking crimes committed by juveniles and suicides by teenagers in reaction to bullying; and the proliferation of teenage prostitution under the pretense of "compensated dating."[11]

9 Takashi Murakami, unpublished notes, November 1991.

10 In conversation with the artist, January 22, 1992.

11 Masanobu Ito, *Tastes and Pursuits: Japanese Art in the 1990s*, exh.cat. (Tokyo: The Japan Foundation, 1998): 6.

fig. 4 Kanō Sansetsu (attributed to), *Robai zu (Old Plum Tree)*, 1647
Colors and gold leaf on paper
Sliding door panels, set of four
68 3/4 x 191 1/8 in. (174.5 x 485.3 cm)
The Metropolitan Museum of Art, The Harry G. C. Packard Collection of Asian Art, Gift of Harry G. C. Packard
and Purchase, Fletcher, Rogers, Harris Brisbane Dick and Louis V. Bell Funds, Joseph Pulitzer Bequest and the
Annenberg Fund, Inc., Gift, 1975 (1975.268.48)

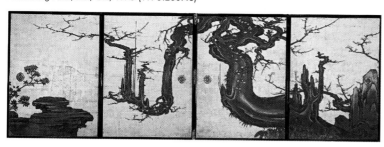

We've read about all this in the newspapers, but condensed into one paragraph it paints a dreadfully bleak picture of the current cultural landscape.

Yet the essayist also observes that "Although these events would seem to have brought us to the verge of crisis, most people do not seem to feel particularly endangered," and he continues with a discussion of the immense popularity of comic books, video games and high-tech microchip toys such as *tamagotchi* electronic pets, as an escape from reality.[12] It is this "cuteness" as a panacea—or is it a placebo?—that Murakami plays with in his characters inspired by Japanese animation, comic books and toy models, sometimes in a friendly way, sometimes as a smirking bully. With DOB, the Disneyesque monkey/mouse, his happy flowers (ironically named "cosmos"), *Dakko-chan* the inflatable doll, or the full size models *KO²*, *Hiropon* and *My Lonesome Cowboy*, he feeds then subverts our expectations for their established identities through unconventional pairings, contortions of their form, or sinister mood shifts, reminding us that, in reality as well as fantasy, cute, sentimental playfulness can easily be turned into something quite different.

The concept of responsibility in Japan is different from that in the West, in part because of a tendency to avoid absolutes in favor of "situational" understandings. For example, rather than set a particular policy, the Japanese prefer to make decisions on a "case by case" basis. Consensus, or group participation in decision making—whether actual or in appearance only—produces a circular responsibility with a hollow center; an individual will agree to a group decision as long as the person on either side does the same. In his important study of the Japanese system of government, bureaucracy and business, *The Enigma of Japanese Power*, Karel van Wolferen writes that to find the source of

power "is like groping in the proverbial bucket of eels. The lines of command, the focus of responsibility, the ins and outs of decision-making, all remain maddeningly elusive."[13] Murakami gathers some of the slippery eels of militarism, nationalism, racism and environmentalism and dresses them in the clothing of childhood innocence, interrogating some of the major contradictions found within Japanese society.

Japanese Culture and Westernization

It is essential to understand the "island mindset" that shapes Japanese culture and the ambiguity still felt toward things non-native.[14] This has had an effect on contemporary artists with international aspirations like Murakami. Critic Fumio Nanjo outlines the dilemma:

> The problem is one of position: where does an artist place himself in relation to the complex issues of localism, internationalism, Modernism and tradition? When a Japanese artist intends to create an original work of art, he is frequently in danger of falling into the trap of an exotic *Japonisme* for which *ukiyo-e* was once praised in Europe. On the other hand, if he were to produce work similar to Western contemporary art, he would run the risk of being regarded as an imitator...the question is, how can an artist present an international and universal work of art without losing his own cultural and national identity?[15]

The social customs and personal behavior of Japanese today are rooted in geographic, historical and religious factors stretching back centuries, but another key factor in today's Japan is the surrender terms worked out between the Japanese Emperor and the American forces. By allowing the Emperor, considered a divine leader, to survive as the head

12 Ibid., 7.

13 Karel van Wolferen, *The Enigma of Japanese Power* (New York: Vintage, 1990): 26.

14 In language and cultural spirit, one senses a clear division between what is Japanese and what is not: *gai-jin*, the word for foreigner, is represented by the two characters for "outside" and "person," *katakana*, a whole different alphabet, is used for imported words, and *Nihonginron* (Theory of Japanese People) a whole category of writing, exists to explain the citizens' uniqueness. Through the educational system, steeped in national history, and other group-oriented forces, a heightened cultural identity is fostered.

15 Fumio Nanjo, "Situation japonaise," *Les Cahiers du Musée national d'art moderne* 28 (Summer 1989). Original in French, quote from p. 7 of an unpublished English translation prepared by Nanjo and Associates, Tokyo.

pl. 5 Takashi Murakami, *Kase Taishuu Project* (detail), 1994
C-prints, photocopies and video
4 parts, 32 x 24 1/2 in. each (82 x 62 cm)
22 parts, 12 x 8 3/4 in. each (30.5 x 22 cm)
Dimensions variable
Courtesy of the artist, P-House (ZAP), Tokyo, and Marianne
Boesky Gallery, New York

pl. 6 Takashi Murakami, *ZuZaZaZaZaZa*, 1994
Acrylic and silkscreen on canvas
60 x 68 in. (150 x 170 cm)
Collection of Ryutaro Takahashi; courtesy of
Tomio Koyama Gallery, Tokyo

of a constitutional monarchy, and by permitting many of the bureaucratic and corporate leaders within the prewar Japanese system to remain in their positions, the core of traditional Japanese social and political structure was ensured. Nevertheless, many Japanese read the American victory as a signal of the superiority of the American way. "When I was in junior high school, my father talked to me every day about America," Murakami recently recalled about his father's grateful devotion to the "America" he absorbed through his job at the naval base, "so I have a lot of personal influence from American culture."[16]

Murakami does not necessarily seek to present what Nanjo calls the "international and universal work of art," and this has worked both for and against his reception at home and abroad. He doesn't hesitate to focus on Japan-specific phenomena (such as *randoseru*, Kase Taishuu and *otaku* culture) that may be difficult for outsiders to understand immediately. "I just like things that are not universal,"[17] he once quipped. Running counter to the more abstract, spiritual, Buddhist-inspired Japanese art such as Tatsuo Miyajima's stunning installations of electronic digital diodes or Hiroshi Sugimoto's seascape series *Time Exposed*, Murakami taps into the particulars of his country. "My idea is to see the reality of our life not in the universal, but in the details."[18] This strategy is linked to his apprehension about the expanding economic power of Japan during the "bubble era"—concern that the country had a mistakenly inflated sense of its place in the world. "In the '80s Japan had great pride, we thought we knew everything, but I want the Japanese to see the reality—that we are really just a small country—so I focused on the [local] details."[19] For example, he often uses Japanese slang, or lifts onomatopoetic fragments from comic

books (*ZuZaZaZaZaZa* is the sound of a baseball player sliding into a base) or from other popular entertainment. One early work is a sign declaring (ironically, in roman letters) "Dobozite, Dobozite, Oshamanbe" (pl. 4). The first two words are a funny way of saying "Why?" copying the rural twang of "Inakappe Taisho" ("Chief Country Bumpkin"), a popular animated television show from the 1970s, while "Oshamanbe" is taken from a gag from the comedian Toru Yuri.[20] Although his references are from the mass media, only a narrow slice of today's Japanese can necessarily "read" the connections. The work of Murakami and others of his generation has been labeled "Neo-Pop," but this is a Pop art far from the common imagery of Andy Warhol's soup cans and Jasper Johns's flags or numbers, or even Tadanori Yokoo's recognizable actors or Ushio Shinohara's motorcyclists from Japan's own 1960s Pop art.

Murakami will often focus on the tension between Japanese traditions and the modernized, Westernized Japan of today. For example, on the afternoon of the day that the *Sansei no Hantai na no da* exhibition opened, he arranged for a Shinto priest to perform a purification ritual for animals sacrificed for the *Randoseru Project* (see fig. 2).[21] During the opening reception, a soundtrack with songs of nostalgia, America and youth culture put together by a DJ friend, Hiroshi Nakajima, was played to extend the connections to pop culture.[22] Also that evening, in keeping with the pricey status of the luxury leather bags, smiley, professional trade-show models in coordinated outfits helped show off the goods, an extension of the department store culture that, while originally imported from the West a century earlier, has been elevated to an art form by Japanese corporate marketers.

16 Telephone conversation with the artist, June 22, 1999.

17 Takashi Murakami, fax letter to Midori Matsui, cited in *Takashi Murakami: Which Is Tomorrow?—Fall in Love*, 49.

18 Telephone conversation with the artist, June 22, 1999.

19 Ibid.

20 Murakami, fax letter to Matsui, in *Takashi Murakami: Which Is Tomorrow?—Fall in Love*, 49.

21 While such ceremonies may be traced back to animistic beliefs and the culture's agrarian roots, such as the blessing of land before harvest, today Shinto ceremonies are held for more prosaic occurrences, such as the ground-breaking for a new apartment building or the purchase of a new car.

22 Songs included "Yesterday Once More" by the Carpenters, "Spirit of America" by the Beach Boys, "ABC" by the Jackson 5, "Waterloo Sunset" by the Kinks and "Revolutionary Generation" by Public Enemy.

pl. 12 Takashi Murakami, *Klein's Pot A*, 1994–97
Acrylic on canvas on board
15 1/4 x 15 1/4 x 3 1/4 in. (39 x 39 x 8 cm)
Collection of Barry Blumberg, Los Angeles;
courtesy of Blum & Poe, Santa Monica

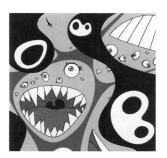

pl. 24 Takashi Murakami, *Chaos*, 1998
Acrylic on canvas on board
15 7/8 x 15 7/8 x 1 3/4 in.
(40.5 x 40.5 x 4.5 cm)
Collection of Neuberger Berman, LLC,
New York

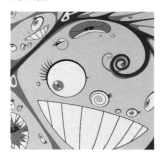

Although today's Japanese department store is a shopper's paradise, where consumption of a continual stream of newer, faster, bigger, better products is encouraged as a national pastime (to ensure the economic infrastructure and job security), the country was not always such a capitalist-driven, consumer-oriented society. With the political shifts and opening of borders in the 1860s, the country modernized and Westernized away from its agriculture-focused, feudal system. The Japanese became more urban, better informed, more aware and even envious of foreign ways and wares. Since the early twentieth century, fads and fashions have swept across the archipelago, the flames fanned by the country's *zaibatsu* conglomerates, which import or produce, then market and distribute, a continual stream of merchandise. Murakami is a child of this culture and in his Hiropon Factory he has created his own version of the Japanese production and trading company. He employs a team of talented young artists who help produce a wide range of goods and accessories, from souvenir t-shirts emblazoned with DOB and other characters to watches, key chains, plastic models and plush toys. In fact, his products have had such a wide appeal he has even found counterfeit DOB dolls in Southeast Asia.[23] While Westerners draw a strong line between the fine and commercial arts (Andy Warhol was one of the few allowed to straddle both), Murakami purposefully plays both sides, capitalizing on his popularity and success as any good Japanese businessman would.

Implicit in any exploration of Japanese-ness are questions of racial pride. Official Japan fuels the coherence and cooperation in society by promoting the myth that throughout history Japan has been a monoculture (that is, "We Japanese"). While all foreigners are termed *gai-jin,* or "outside people," Japan looks upon Westerners, especially Americans, with greater favor, while African,

Middle Eastern, Oceanic and other Asian cultures are distanced and exoticized. The proximity of the naval base would have no doubt exposed the young Murakami to Americans with a range of cultural backgrounds. In recent decades outside critics have taken the Japanese media, business conglomerates and politicians to task for racism or harmful cultural ignorance. Writing in *The Japan Times,* African-American columnist Karen Hill Anton explains, "Discrimination, and its cousins, prejudice and racial chauvinism, course through every level of Japanese society, and are alive and thriving in this island country." But the situation is not limited to black foreigners, she continues, as "generations of ethnic Koreans, *Ainu, Burakumin,* and others who have been excluded from the socioeconomic prosperity of the mainstream can affirm its existence."[24] Nevertheless, the studies of cultural anthropologist John G. Russell reveal that Japanese racism is inextricably linked with its relationship with the West, as Japanese racism can be traced back to the sixteenth century, when Africans were among the Dutch and Portuguese crews who landed at Japanese ports.[25]

Whenever charges of racism are raised, fast, easy but nonetheless superficial gestures have been taken to repress the appearance of racism, such as the elimination of the book *Little Black Sambo.* Murakami mocks this knee-jerk political correctness with a multiple he produced in 1991 as part of his *Wild Wild* exhibition, a whitewashed version of a ubiquitous toy from his youth, *Dakko-chan* (Little Darkie), an inflatable, all-black cling toy with big lips, curly hair, a big gold earring and empty eyes—an obviously cute-ified African/monkey caricature. Murakami's version (fig. 3) is completely white and has big (still empty) blue eyes and curly blond hair. As foreign as the original, its appearance as a counter-critique of the critique of racism reveals Murakami's acumen for slipping into a dialogue about political and social issues without

23 In commemoration, he created a t-shirt featuring the DOB knockoff under which is written in Murakami's hand, "Who I Am?"

24 Karen Hill Anton, "Japan Faces the Ugly Truth of Racial Discrimination," *The Japan Times,* December 7, 1991: 23.

25 See John G. Russell, *Japanese Perceptions of Blacks: The Problem Is More than Little Black Sambo* (in Japanese) (Tokyo: Shinhyoron Press, 1992). See also "Narratives of Denial: Racial Chauvinism and the Image of the Black Other in Contemporary Japan," *Japan Quarterly* (October/December 1991) or "Race and Reflexivity: The Black Other in Contemporary Japanese Mass Culture," *Cultural Anthropology* 6 (February 1991): 3–25.

pl. 39 Takashi Murakami, *The Castle of Tin Tin*, 1998
Acrylic on canvas on board
120 x 120 in. (300 x 300 cm)
Private Collection, Los Angeles; courtesy of Blum & Poe,
Santa Monica, and Tomio Koyama Gallery, Tokyo

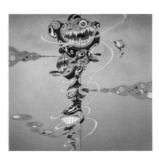

pl. 15 Takashi Murakami, *Miss KO²*, 1997
Oil, acrylic, fiberglass and iron
100 x 46 x 36 in. (254 x 117 x 91.5 cm)
Collection of Marianne Boesky Gallery, New York
Edition 2/3

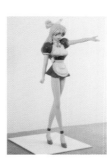

26 Murakami's white *Dakko-chan* made its debut clinging by the hundreds to a large grayish structure which the artist referred to as a giant whale, thus raising another sensitive issue, whale harvesting, for which the Japanese had been criticized.

27 Noi Sawaragi, "Takashi Murakami," *World Art* (Summer 1997): 76.

calling attention to his opinion.²⁶ *Dakko-chan's* appearance in *Fall in Love* (1995, pl. 7), cuddling with Murakami's other character, DOB, taunts the Japanese idea of racial purity by celebrating a cross-cultural (and cross-species) pairing, a saccharine-sweet version of love and cultural difference that nonetheless is too cute for words.

Japanese aesthetic painting issues, too, are a key part of Murakami's localized/globalized oeuvre. The artist received the first Ph.D. in *nihon-ga*, the national (and nationalistic) painting style using natural pigments and traditional subject matter. The Japanese art critic Noi Sawaragi has addressed Murakami's position between Japan and the United States:

> Murakami recognizes that the symbols that identify "Japan" have been formed not by the accretion of ancient traditions but by gathering various elements artificially in the process of modernization, and he is able to draw, in his criticisms, on his thorough training within the tradition of *nihon-ga*.²⁷

Murakami has played with the strong sociopolitical significance of *nihon-ga* within Japan, as well as its outsider status in the world of contemporary art. His early monochromatic abstractions in natural pigments are anomalous in both fields. In works such as *727* (1996, pl. 9) and *And then and then and then and then and then* (1996–97, pl. 17), he gives the painting a richly textured, subtly colored surface by sanding through layers of color, which seems contradictory to the slick, cartoony subject matter. But Murakami looks back to even earlier traditions. Within the Japanese landscape painting tradition, he is especially interested in Kanō Sansetsu (1590–1651), whose mannered, floating "naturescapes" feature organic elements hung in vast empty fields (fig. 4). Murakami's four-panel

structure for *Splash* paintings such as *Milk* and *Cream* (both 1998, pls. 36, 37) suggests a Japanese folding screen, traditionally ornamented with a landscape (often rendered as sparsely as a few isolated cloud forms). The fluidity of Murakami's splashes recalls the dramatic wave imagery in Hokusai's famous woodblock prints, but their jagged forms can also be read as lightning flashes, which in *ukiyo-e kabuki* prints symbolize ghosts or spirits. The sweeping, thrusting strokes Murakami employs also suggest calligraphy, another important traditional Japanese art form. The direct source for these works is actually quite contemporary: Yoshinori Kanada's *Goodbye to Galaxy Railway 999*, an animated science fiction film about the primal beginnings of the world.

We can also look upon these works in relation to American Abstract Expressionism, once described as "the triumph of American painting." Although *Milk* and *Cream* fit the epic scale of that period, and their aggressive, dynamic energy suggests Jackson Pollock, Robert Motherwell or Willem de Kooning, the illustrational outlines more accurately evince Roy Lichtenstein's parodic interpretations of that movement, making these works cross-generational, cross-cultural dialogues. Murakami's practice is deeply rooted in Japanese culture, but incorporates and interrogates aspects of its Westernization. In this way he reveals the uniquely assimilated Westernized aspects of Japanese culture within an increasingly global one, as well as the lingering pleasures—and social significance—of the local.

Individualism and Society

Japan is often said to be a group-oriented society valuing cooperative interdependence over strident independence. The needs of the individual are sublimated for the common good; the Japanese individual is said to contextualize his or her identity

to play a specific role in a particular context. Van Wolferen writes, "Japanese are expected to stick to their roles, and to make the roles clear with their dress, speech and behavior. There is an easily recognizable mother role, housewife role, *sempai* [mentor] role, boss role and apprentice role, to mention only the most obvious."[28] And yet, several years ago, a book by Yamazaki Masakazu challenged this mythic Japanese group mentality, making a case for the slow reemergence of a "gentle individualism" found in cultural spheres of earlier epochs, now all but extinguished by postwar corporate culture.[29] This is in many ways evident in today's emerging generations, from the newly minted salaryman who expects to have time for family, friends and vacations, to the especially colorful youth tribes of Tokyo's Shibuya entertainment/shopping district. In a number of works, Murakami pushes forward representations of individuality that overturn conventional ideas about an individual's relation to society. Japan has a highly developed pop music industry with a strong but competitive, ever-changing cast of performers, producers, publicists and presenters; the results are high stakes and big business. In the *Kase Taishuu Project* (1994, pl. 5), Murakami's intervention into the pop music world, the artist responded to a highly publicized dispute between the singer Kase Taishuu and his manager. The manager, who felt he had the rights to the name since he had developed the performer's fame, hired a "New Kase Taishuu" when the first one left his management. To increase the irony of this already ludicrous situation, Murakami publicly announced the existence of four *other* Kase Taishuus, drawing attention from the national popular media. First one, then two, then six young men, all claiming the same "identity," were part of a commercial packaging game that undermined the whole idea of unique talent, and of the individual.

Murakami's own artistic practice undermines the model of a sole artistic hand making unique masterpieces in favor of producing a broad product line. While he is certainly the creative director of the Hiropon Factory, as he calls his studio and offices, a team of assistants with a variety of skills help him produce his works—from unique paintings and sculptures based on his drawings to t-shirt designs and computer animated logos. He seems to cherish this communal spirit of the Hiropon Factory, as it fuels and extends his creativity, and serves to inspire the individual work of its participants.[30] This collaborative network is also part of the content and context of his work, and a way in which he reaches out to his audiences. He even publishes the *Hiropon Factory Newsletter*, like a fanzine, which broadens the visibility of his brand identity.

Murakami's animated characters are readily recognizable, although they have shifted their form and personality as he has developed his innumerable representations of them. DOB started as a simple, smiling mouse, a big head on a small body, as in such works as *ZuZaZaZaZaZa* (1994, pl. 6) and *Fall in Love*. He reveals more emotion in balloons and in paintings with close-ups of the face such as *And then and then and then and then and then*. The character would soon melt, morph or multiply into even wilder manifestations. In *Klein's Pot A, B* and *C* (1997, pls. 12–14) the transformation suggests that a deformed DOB inflatable is pushing against our window, its features rearranged into a terrible tangle. *Chaos* (1998, pl. 24), one of a set of stretched and twisted DOB figures on silver grounds, presents the familiar face as a network of cells stretching out in all directions. In the monumental *The Castle of Tin Tin* (1998, pl. 39) a dynamic vertical totem of DOBs spins within a spiky corkscrew of splashed paint while candy-colored streams spew from several open mouths.

28 Van Wolferen, 333.

29 Yamazaki Masakazu, *Individualism and the Japanese* (Tokyo: Japan Echo, 1994): 73.

30 The Hiropon Factory also seems to serve other roles. Murakami arranged for a show of members' works in a Los Angeles gallery, and once when I visited he was leading a formal group critique of artwork by staff that was hung around the office or screened on video or computer terminals.

fig. 5 Takashi Murakami, *S.M.PKO² Megamix*, 1999
Model kit
34 1/2 x 28 x 16 in.
(87.5 x 72 x 40 cm)
Courtesy of the artist

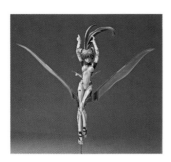

31 Telephone conversation
with the artist, June 22, 1999.

Miss KO² (1997, pl. 15) first appeared as a simple, wide-eyed young woman in a waitress uniform, reaching out to the viewer. She now exists as a life-size painted fiberglass sculpture, a doll-sized plastic model kit sold as a limited edition by the artist (fig. 5), and illustrated on t-shirts. Murakami is currently working on a futuristic version, a three-stage sculpture entitled *Second Mission Project KO²* (see pl. 8, an early drawing study for the sculpture), in which she appears first in a silvery space-age body suit that begins to transmogrify into a jet fighter plane, shifting from flesh to machine, from feminine to masculine, from passive to aggressive. The second stage focuses on the instrument of destruction itself, and in its final stage *KO²* reemerges as if from a cocoon, back from the life of a superhero wondergirl.

Other characters declare their independence singularly. The buxom, buoyantly athletic *Hiropon* (1997, pl. 16) is far from the typically demure Japanese girl. Active, assertive, self-sufficient and openly joyful, she poses a threat to the *otaku* culture that she was created to address—all the while that she skips on past. *My Lonesome Cowboy* (1998, pl. 38) is an unabashed, unfettered display of male potency and self gratifying pleasure that runs counter to the expectations for a typical Japanese young man to be discreet and avoid outward displays of emotion. It might instead be closer to the young *otaku* male fantasy of sex without contact with another human being.

Murakami's most recent project, *DOB in the Strange Forest* (1999, pl. 44), also seems to relate in some ways to these issues of individuality. Appearing here in his initial, straightforward style, DOB is an outsider among the twelve variegated polka-dotted mushrooms covered with multiple eyes. These funny new fungal characters, Murakami explains, were in part inspired by the mushroom towel designs of

Taisho-era artist Takahisa Yumeji, who sought to find a balance between fine and applied, or popular, arts, and "used the mushroom as a cute motif that appealed to female taste."[31] Other crossover referential implications include their phallic shape, their propensity to propagate quickly, *Alice in Wonderland*, and the hallucinogenic properties of certain species. The atomic mushroom cloud, an image Murakami blew up to monumental mural scale in *Time Bokan* (1993), marks another mushroom metaphor that plays off of the seeming cuteness of those he has produced here.

These are not ordinary mushrooms. Under their colorful caps, the gills of the fungus have been transformed into horrific, razor-sharp teeth suggesting the surrealistic *vagina dentata* of Pablo Picasso's most aggressive female portraits. Covered with eyes they become all seeing, observant of the skinny and lonely DOB's every move. Could this refer to *otaku* culture, isolated individuals propagating their networks under the cover of night, "all eyes," watching the world but never acting on their own two feet? Or is this scene a microcosm of Japanese group dynamics, where everyone watches the behavior of everyone else and inherently nullifies individuality? Anyone who has worked in a Japanese office will recognize the power of the watchful and controlling gaze.

Meaning and Nonsense
Given Murakami's exploration of childhood innocence and adult responsibility, Japanese-ness and Westernization, and individualism and society, the work on view in this exhibition seems rich with meaning, not nonsense. It is true that he has, at different points in his career, sought to undermine viewers' attempts to make full sense of his artistic activities. For example, he often expands upon the trivia (and triviality) of national advertising

pl. **3** Takashi Murakami, *Lucky Seven Stars*, 1993
Cigarette boxes, LED and computer
5 3/4 x 50 3/4 x 3 1/2 in. (14.5 x 129 x 9 cm)
Collection of the artist; courtesy of Tomio Koyama Gallery, Tokyo

fig. **6** Takashi Murakami, *Sea Breeze*, 1992
Mixed media
138 x 189 x 98 1/2 in. (350 x 480 x 250 cm)
Courtesy of the artist and Röntgen Kunst Institut

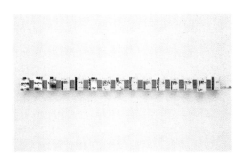

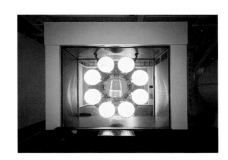

campaigns. *Lucky Seven Stars* (1993, pl. 3) was inspired by the marketing of a series of variations on a single cigarette brand. He explains:

> I wanted to make something that wasn't art but looked like art, and I also wanted (as indeed I still do) to create an "art work" from something that couldn't really be considered art. The result, thanks to the superb skills of my assistant, turned out to be a really amusing work of art.[32]

About *Sea Breeze* (1992, fig. 6), a shuttered box of high intensity stadium lights on wheels, he wrote two years later that "the work itself does not have any concept. Just an enormous work who's ground of art is collapsed."[33] A special performance around the monumental mechanical object on the night of its debut was, he noted, "carried out by a naked hula-hooper, a man who was disguised as the Emperor, an opera singer and two puppies...[all] from different contexts." He concluded, "I have been using [this] ambivalent way of representation to repeat [a] construction and deconstruction of the context of art."[34] This Dadaesque escapade was bound to pique both curiosity and outrage, and when discussing *Sea Breeze* recently Murakami revealed that the work and his dismissive commentary were really aimed to distract the Japanese art critics who had just discovered his work, as he felt that they were making too much of his interests in social issues so that they could link it to the new vogue in "Political Art." Instead, he offered a spectacle of bright lights, loud noise, exotic dancing and wild costumes. Like the fabled "emperor's new clothes," there is meaning even in this nonsense. In the same discussion he uncovered some of its political content, observing that the sculpture's bright lights were surrogates for the blasters of the U.S. spaceships that had so inspired him in his youth, and, sadly, this indoor artworld spectacle was the closest the Japanese would get to a space program.[35]

Murakami has always believed in the power of art to convey complex ideas about contemporary culture. He pursues this path in his independent way, and sometimes cuteness, play and nonsense are part of his strategy. In 1994 he explained some of the aims of the *Kase Taishuu Project*, which reflect upon the larger critical project he has pursued all along:

> We think that Art in Japan should certainly not function as something "Art-ish" or as "illustration art" but rather as the expressed realism of the weak and the flaccid. Further, identity does not propose an absolute being, but exists only as an uncertain set of the indefinite self and others...Each one of our actions [of Murakami's four new Kase Taishuu talents]—from the meaningless songs to...the street paintings with no meaning and no message—will...determine how boldly and realistically this self-portrait of the Japanese—and ourselves—will come into view.[36]

Murakami's work has had a shifting relationship to Japanese society. Art historian Alexandra Munroe links the critique of political, economic and social systems in Japanese contemporary art of the 1990s to historian Takashi Fujitani saying that the "flattening out of culture—the collapse of history, meaning, and eternal truths—may, in fact, be stimulating a new search for authenticity."[37] Cultural observers have linked the contemporary appeal of new religious sects (including the Aum Shinrikyo cult) as a signal that young people are searching for alternatives to the strict patterns of conventional Japanese life, and the predictable roles that society expects them to fulfill. Murakami's art seriously pursues meaningfulness in an attempt to bring a "new authenticity" of "Japan" into better focus. Sometimes he just finds it in nonsense itself.

32 Murakami, fax letter to Matsui, in *Takashi Murakami: Which Is Tomorrow?—Fall in Love*, 51.

33 Takashi Murakami, "PS1 Project," unpublished text for grant application, 1994.

34 Ibid.

35 Telephone conversation with the artist, June 22, 1999.

36 Murakami, *Marco Polo.*

37 Alexandra Munroe, "Japanese Art of the 1990s," in *Japanese Art After 1945: Scream Against the Sky*, exh. cat. (New York: Abrams, 1994): 341.

TAKASHI

FIRST IN QUALITY AROUND THE WORLD

Works in the Exhibition

Bakabon Project • Polyrhythm • Lucky Sev

Kase Taishuu Project • ZuZaZaZaZaZa • Fal

4, 5, 6 • Merry Go Round • 727 • DOBa •

Pot C • Miss KO² • Hiropon • And then and

Chaos • Chaos • Chaos • Chaos • Chaos

Pigment • HOYOYO • Mr. DOB All Stars • Th

• 4 Monks Sleeping • DOB with Flowers •

Cowboy • The Castle of Tin Tin • Cosmos • Gu

n Stars • **Dobozite Dobozite Oshamanbe** •

n Love • **Sakurako Jet Airplane Nos. 1, 2, 3,**

OBc • **Klein's Pot A** • **Klein's Pot B** • **Klein's**

hen and then and then and then • **Chaos** •

Chaos • **Chaos** • **Mr. DOB DNA** • **Mineral**

End of Summer • **Mollusc** • **Twisting Muscles**

ean of Blue • **Milk** • **Cream** • **My Lonesome**

Guru • **Magic Ball** • **DOB in the Strange Forest**

1. Bakabon Project

1991
Oil on board
5 parts, 13 3/4 x 17 3/4 in. each (49 x 39 cm)
Collection Marunuma Art Park, Saitama-ken, Japan

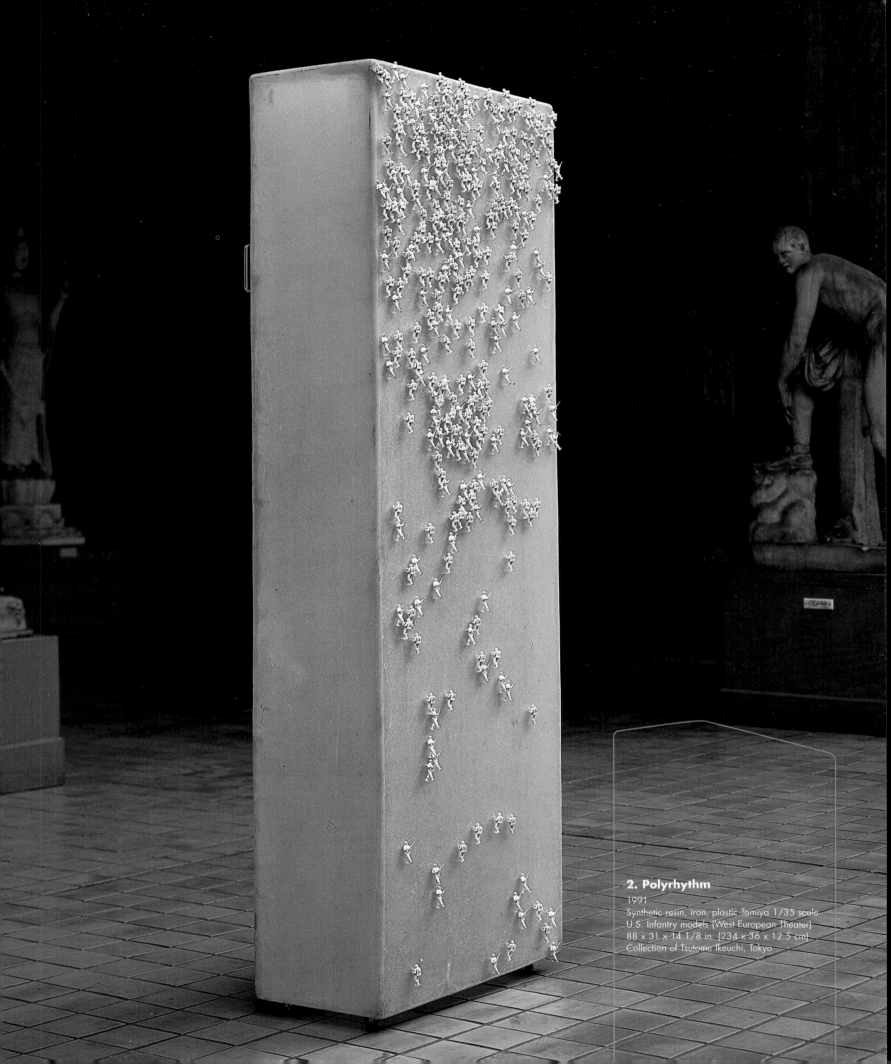

2. Polyrhythm
1991
Synthetic resin, iron, plastic Tamiya 1/35 scale
U.S. Infantry models (West European Theater)
88 x 31 x 14 1/8 in. (234 x 36 x 12.5 cm)
Collection of Tsutomu Ikeuchi, Tokyo

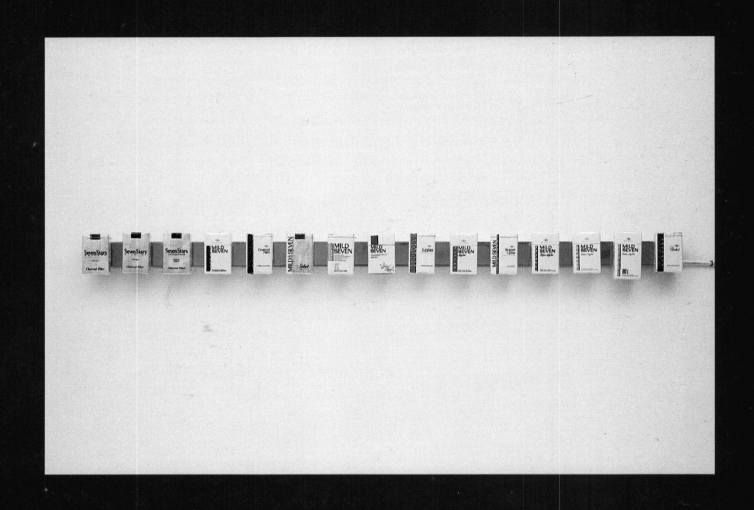

3. Lucky Seven Stars
1993
Cigarette boxes, LED and computer
5 3/4 × 50 3/4 × 3 1/2 in.
(14.5 × 129 × 9 cm)
Collection of the artist; courtesy of
Tomio Koyama Gallery, Tokyo

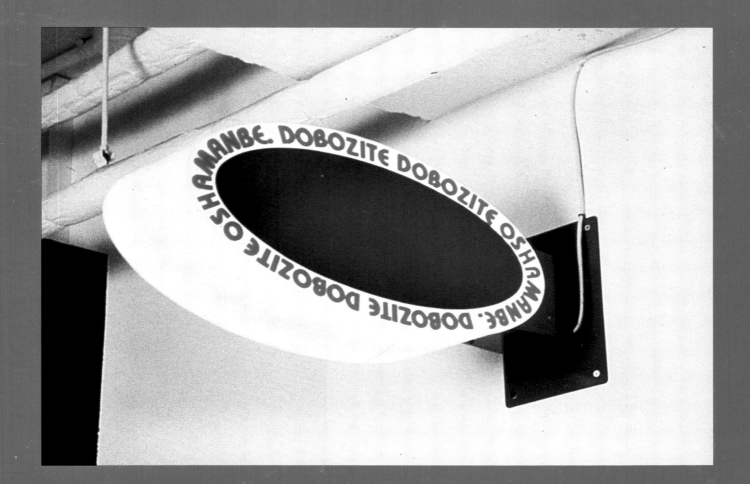

4. Dobozite Dobozite Oshamanbe
1993
Light box
10 1/2 x 30 x 8 in. (26.5 x 76 x 20 cm)
Courtesy of Gallery Cellar, Nagoya, Japan

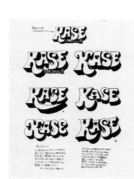

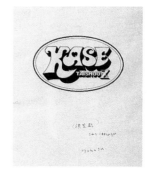

KASE TAISHUU PROJECT

THE ROUTE OF VICTORY

5. Kase Taishuu Project
1994
C-prints, photocopies and video
4 parts, 32 x 24 1/2 in. each (82 x 62 cm)
22 parts, 12 x 8 3/4 in. each (30.5 x 22 cm)
Dimensions variable
Courtesy of the artist, P-House (ZAP), Tokyo, and
Marianne Boesky Gallery, New York

6. ZuZaZaZaZaZa
1994
Acrylic and silkscreen on canvas
60 x 68 in. (150 x 170 cm)
Collection of Ryutaro Takahashi;
courtesy of Tomio Koyama Gallery, Tokyo

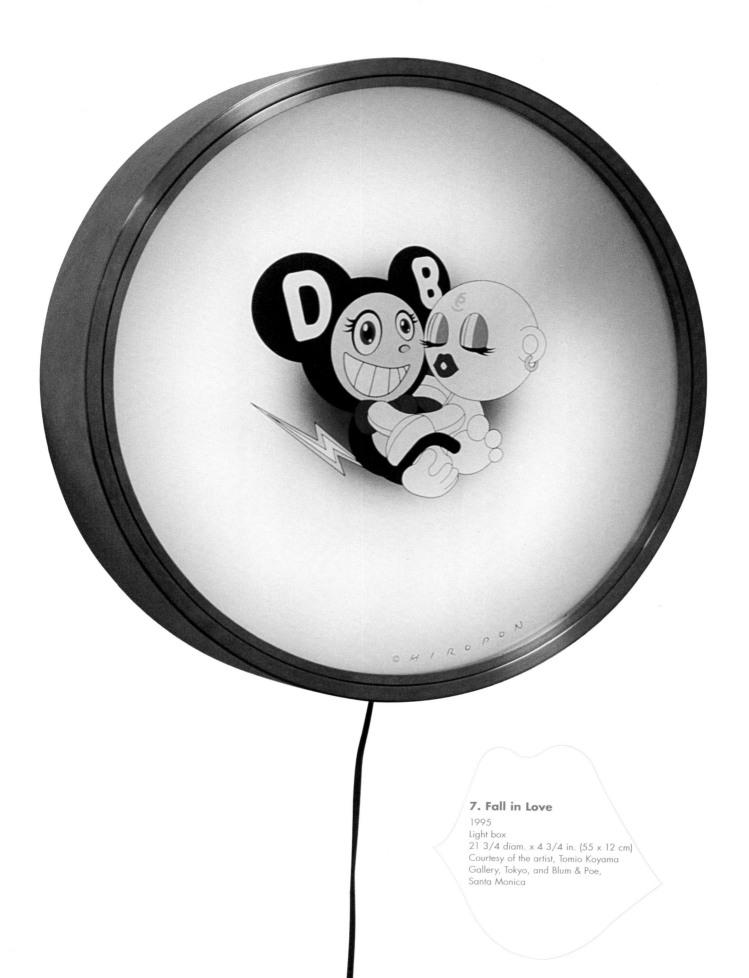

7. Fall in Love
1995
Light box
21 3/4 diam. x 4 3/4 in. (55 x 12 cm)
Courtesy of the artist, Tomio Koyama
Gallery, Tokyo, and Blum & Poe,
Santa Monica

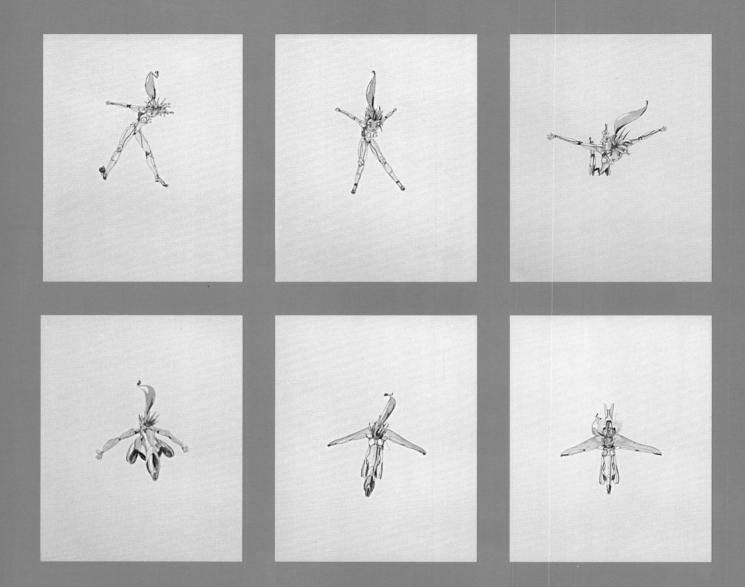

8. Sakurako Jet Airplane Nos. 1, 2, 3, 4, 5, 6
1995
Watercolor on paper
6 parts, 39 1/4 x 46 3/4 in. (100 x 119 cm) total
Collection of Kenneth L. Freed, Boston

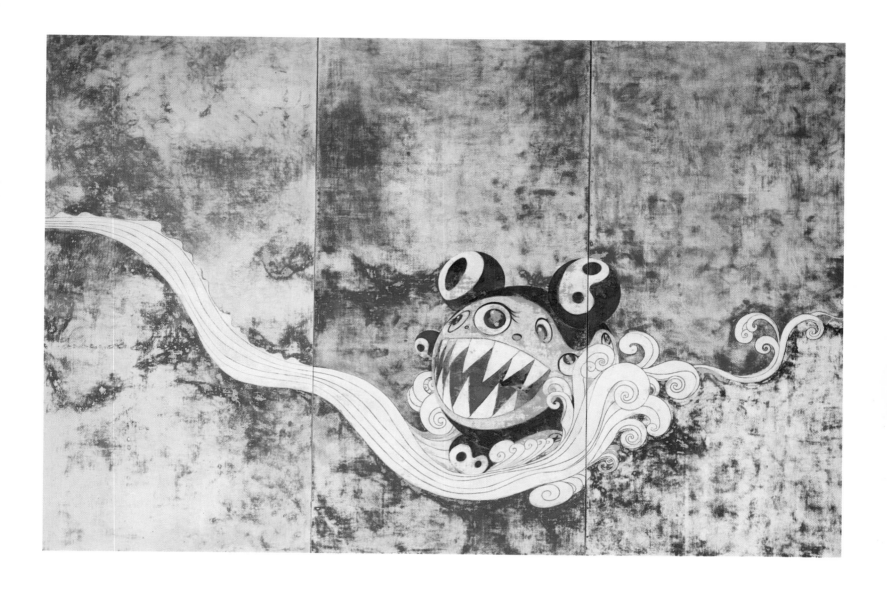

9. 727
1996
Acrylic on canvas on board
118 x 180 in. (300 x 450 cm)
Collection of Misawa Art Project,
Kenji Misawa, Shizaoka, Japan;
courtesy of Tomio Koyama Gallery, Tokyo

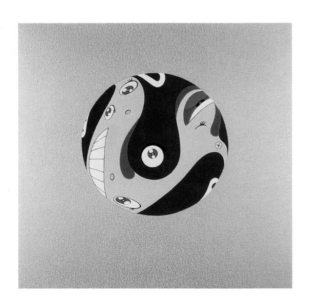

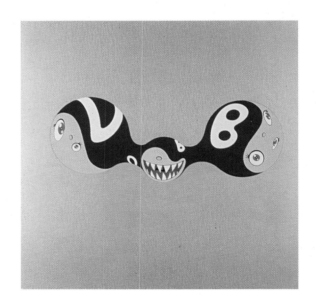

10. DOBa

1996
Acrylic on canvas on board
13 1/2 x 13 1/2 x 1 3/4 in.
(34.5 x 34.5 x 4.5 cm)
Collection of Eileen and Peter Norton,
Santa Monica

11. DOBc

1996
Acrylic on canvas on board
13 1/2 x 13 1/2 x 1 3/4 in.
(34.5 x 34.5 x 4.5 cm)
Collection of Eileen and Peter Norton,
Santa Monica

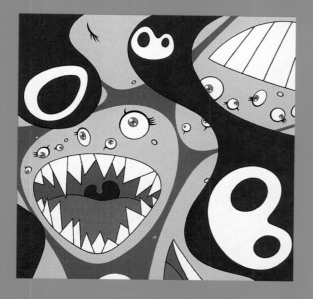

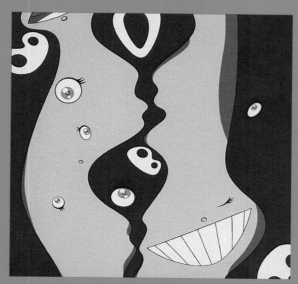

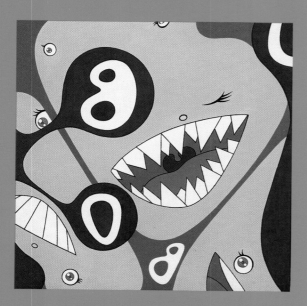

12. Klein's Pot A
1994–97
Acrylic on canvas on board
15 1/4 x 15 1/4 x 3 1/4 in. (39 x 39 x 8 cm)
Collection of Barry Blumberg, Los Angeles;
courtesy of Blum & Poe, Santa Monica

13. Klein's Pot B
1997
Acrylic on canvas on board
13 5/8 x 13 5/8 x 2 1/4 in.
(34.5 x 34.5 x 6 cm)
Collection of Curt Marcus,
New York

14. Klein's Pot C
1997
Acrylic on canvas on board
13 1/4 x 13 1/4 x 2 1/4 in.
(33.5 x 33.5 x 6 cm)
Courtesy of the artist and
Blum & Poe, Santa Monica

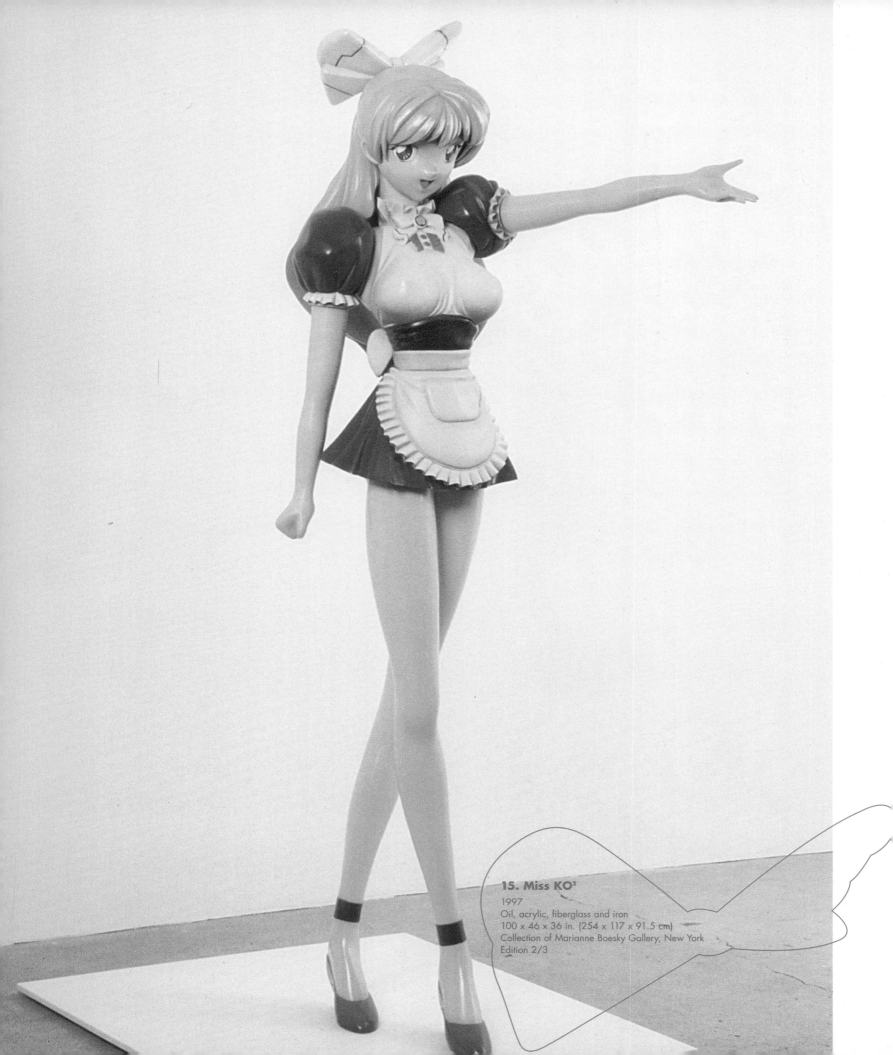

15. Miss KO²
1997
Oil, acrylic, fiberglass and iron
100 x 46 x 36 in. (254 x 117 x 91.5 cm)
Collection of Marianne Boesky Gallery, New York
Edition 2/3

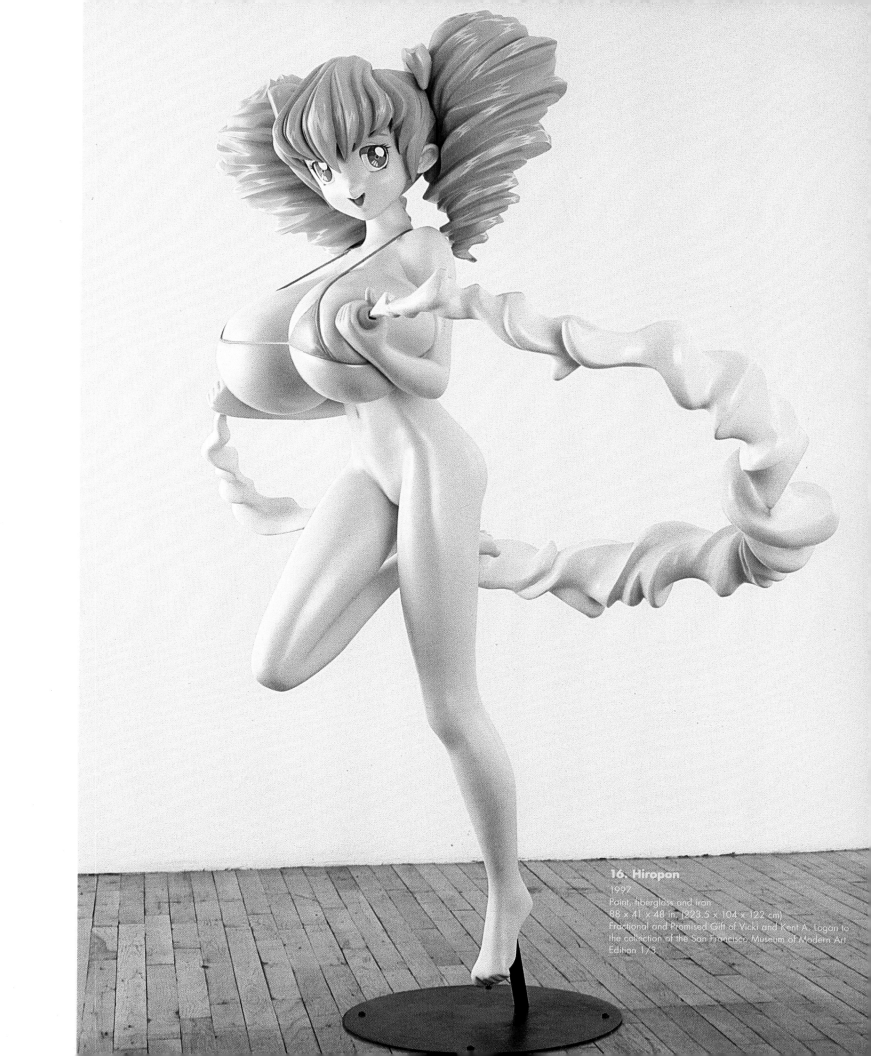

16. Hiropon
1997
Paint, fiberglass and iron
88 x 41 x 48 in. (223.5 x 104 x 122 cm)
Fractional and Promised Gift of Vicki and Kent A. Logan to
the collection of the San Francisco Museum of Modern Art
Edition 1/3

17. And then and then and then and then and then

1996–97
Acrylic on canvas on board
110 1/4 x 118 1/8 in. (280 x 300 cm)
Private Collection, Los Angeles; courtesy
of Blum & Poe, Santa Monica

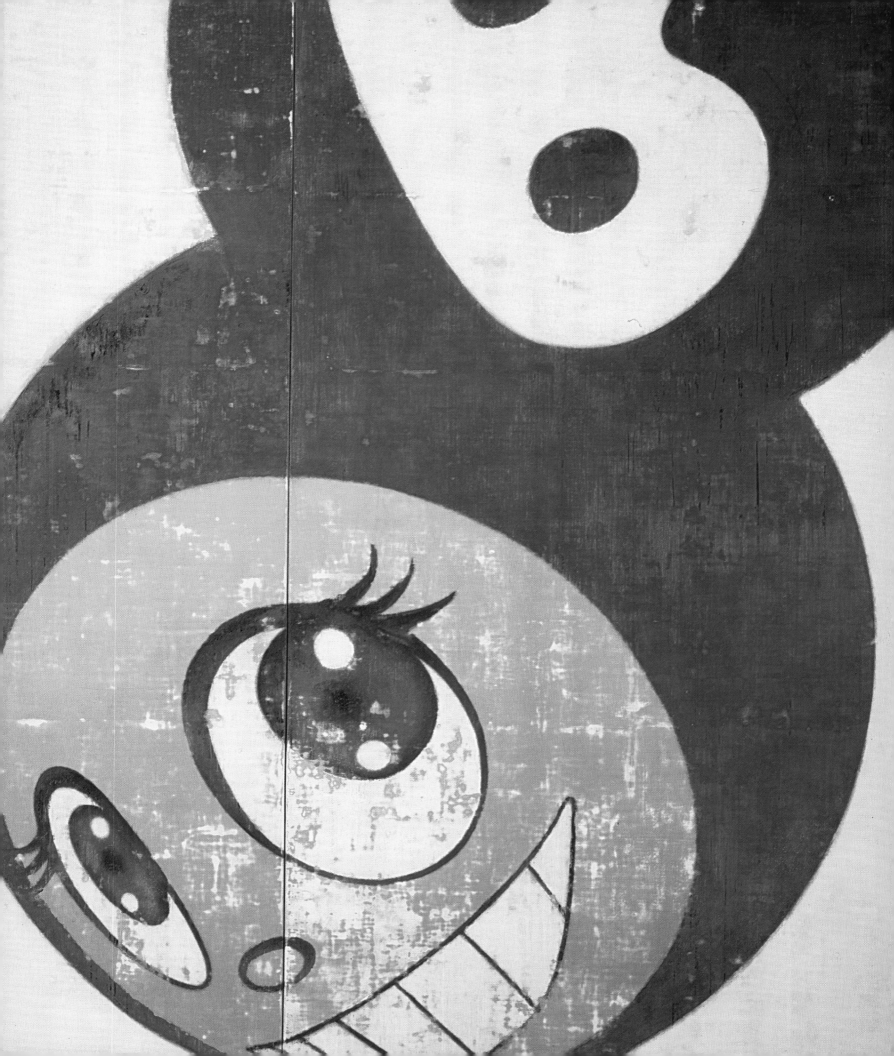

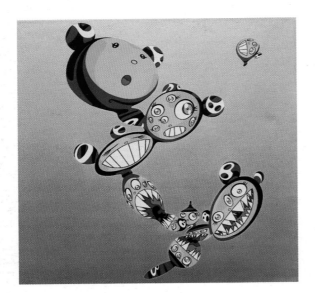

18. Chaos

1998
Acrylic on canvas on board
15 7/8 x 15 7/8 x 1 3/4 in. (40.5 x 40.5 x 4.5 cm)
Collection of Pauline Karpidas, London;
courtesy of Blum & Poe, Santa Monica

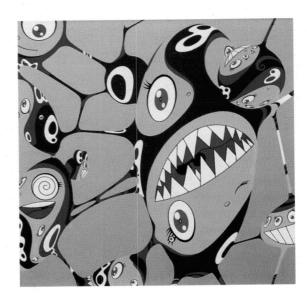

19. Chaos

1998
Acrylic on canvas on board
15 7/8 x 15 7/8 x 1 3/4 in. (40.5 x 40.5 x 4.5 cm)
Collection of Ruth and Jacob Bloom, Beverly Hills;
courtesy of Blum & Poe, Santa Monica

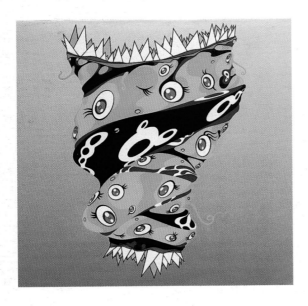

20. Chaos

1998
Acrylic on canvas on board
15 7/8 x 15 7/8 x 1 3/4 in. (40.5 x 40.5 x 4.5 cm)
Courtesy of the artist and Blum & Poe, Santa Monica

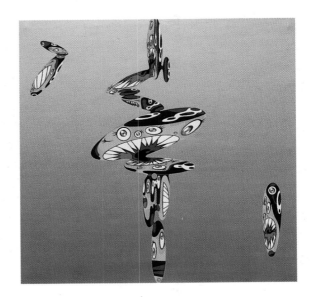

21. Chaos

1998
Acrylic on canvas on board
15 7/8 x 15 7/8 x 1 3/4 in. (40.5 x 40.5 x 4.5 cm)
Courtesy of the artist and Blum & Poe, Santa Monica

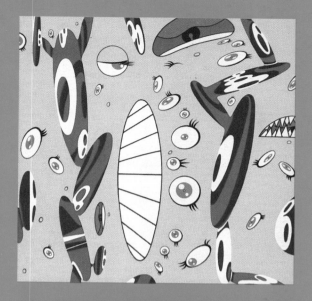

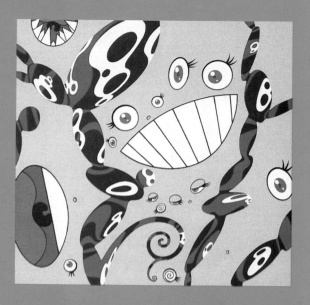

22. Chaos
May 24, 1999
Acrylic on canvas on board
15 7/8 x 15 7/8 x 1 3/4 in. (40.5 x 40.5 x 4.5 cm)
Collection of Darryl Schweber, New York

23. Chaos
1998
Acrylic on canvas on board
15 7/8 x 15 7/8 x 1 3/4 in. (40.5 x 40.5 x 4.5 cm)
Private Collection, London

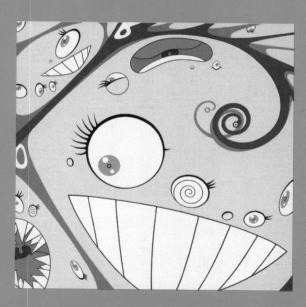

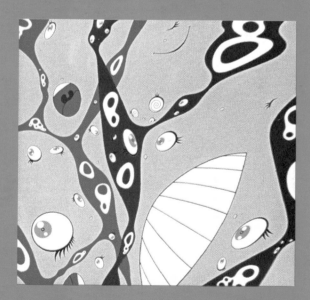

24. Chaos
1998
Acrylic on canvas on board
15 7/8 x 15 7/8 x 1 3/4 in. (40.5 x 40.5 x 4.5 cm)
Collection of Neuberger Berman, LLC, New York

25. Chaos
1998
Acrylic on canvas on board
15 7/8 x 15 7/8 x 1 3/4 in. (40.5 x 40.5 x 4.5 cm)
The Ann and Mel Schaffer Family Collection, New Jersey

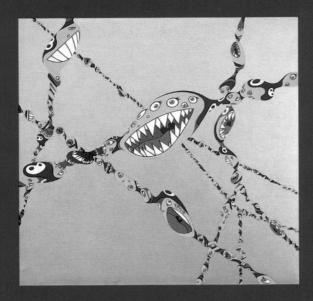

26. Mr. DOB DNA

1998
Acrylic on canvas on board
15 7/8 x 15 7/8 x 1 3/4 in. (40.5 x 40.5 x 4.5 cm)
Collection of Kenneth L. Freed, Boston

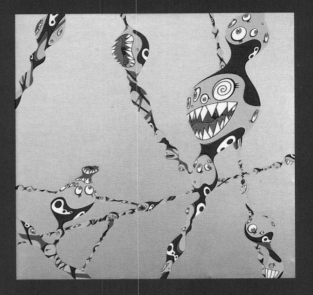

27. Mineral Pigment

1998
Acrylic on canvas on board
15 7/8 x 15 7/8 x 1 3/4 in. (40.5 x 40.5 x 4.5 cm)
Collection of Stavros Merjos, Venice, California;
courtesy of Blum & Poe, Santa Monica

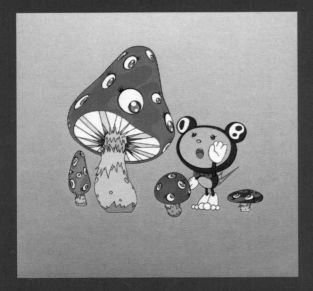

28. HOYOYO

1998
Acrylic on canvas on board
15 7/8 x 15 7/8 x 1 3/4 in. (40.5 x 40.5 x 4.5 cm)
Collection of Hisanao Minoura, Aichi, Japan;
courtesy of Tomio Koyama Gallery, Tokyo

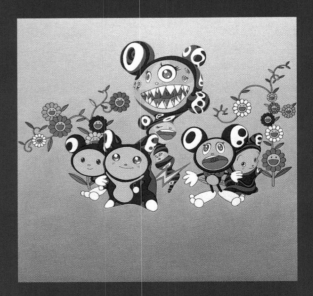

29. Mr. DOB All Stars

1998
Acrylic on canvas on board
15 7/8 x 15 7/8 x 1 3/4 in. (40.5 x 40.5 x 4.5 cm)
Collection of Jason and Michelle Rubell, Miami Beach;
courtesy of Tomio Koyama Gallery, Tokyo

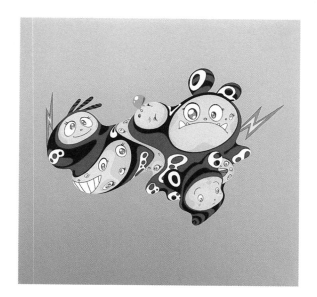

30. The End of Summer
1998
Acrylic on canvas on board
15 7/8 x 15 7/8 x 1 3/4 in. (40.5 x 40.5 x 4.5 cm)
Collection of Roderic Steinkamp, New York;
courtesy of Tomio Koyama Gallery, Tokyo

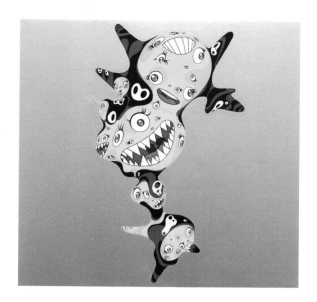

31. Mollusc
1998
Acrylic on canvas on board
15 7/8 x 15 7/8 x 1 3/4 in. (40.5 x 40.5 x 4.5 cm)
Collection of Shinichi Shimizu, Gunma, Japan;
courtesy of Tomio Koyama Gallery, Tokyo

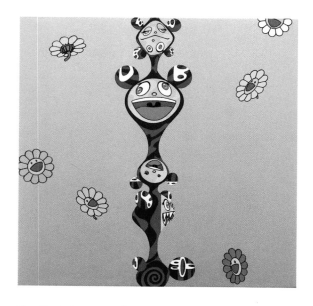

32. Twisting Muscles
1998
Acrylic on canvas on board
15 7/8 x 15 7/8 x 1 3/4 in. (40.5 x 40.5 x 4.5 cm)
Collection of Salucoro Mizutani;
courtesy of Tomio Koyama Gallery, Tokyo

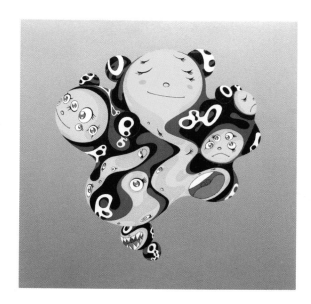

33. 4 Monks Sleeping
1998
Acrylic on canvas on board
15 7/8 x 15 7/8 x 1 3/4 in. (40.5 x 40.5 x 4.5 cm)
Collection of Jason and Michelle Rubell, Miami Beach;
courtesy of Tomio Koyama Gallery, Tokyo

34. DOB with Flowers

1998
Acrylic on canvas on board
15 7/8 x 15 7/8 x 1 3/4 in.
(40.5 x 40.5 x 4.5 cm)
Collection of Kim and John Knight,
Larkspur, California

35. Mean of Blue
1998
Acrylic on canvas on board
15 7/8 x 15 7/8 x 1 3/4 in.
(40.5 x 40.5 x 4.5 cm)
Collection of Roderic Steinkamp, New
York; courtesy of Tomio
Koyama Gallery, Tokyo

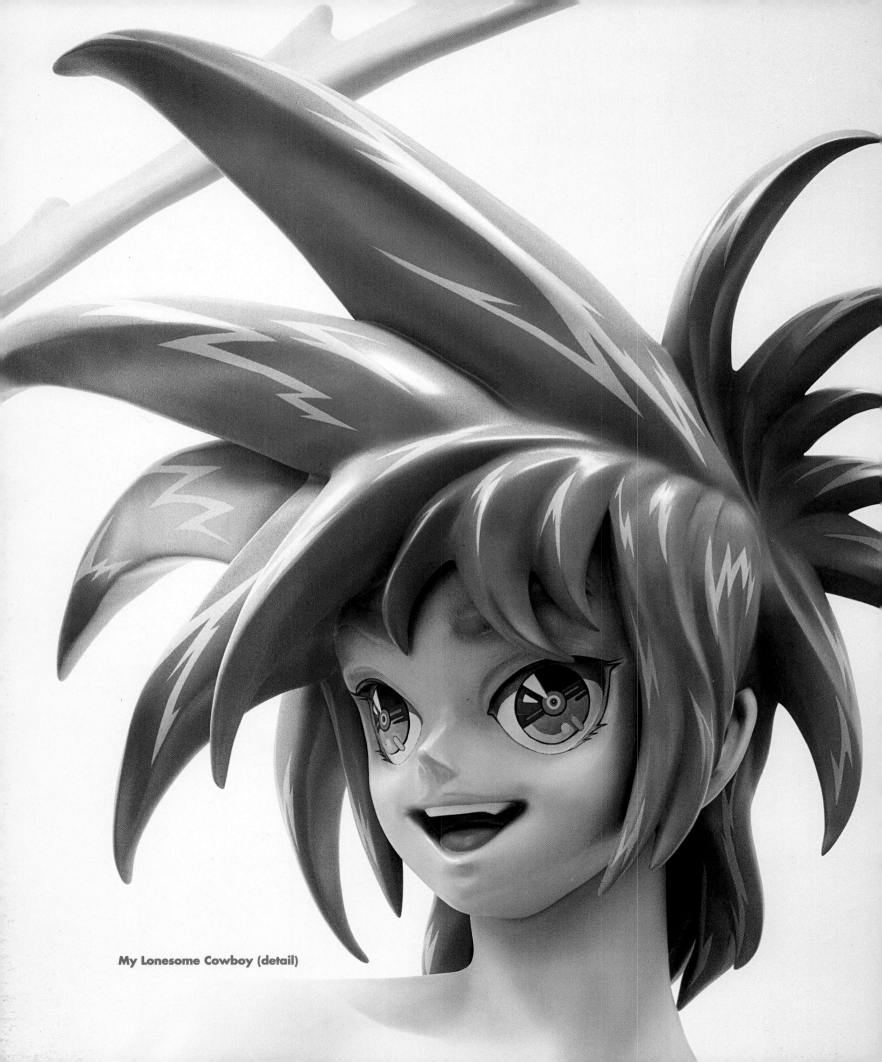

My Lonesome Cowboy (detail)

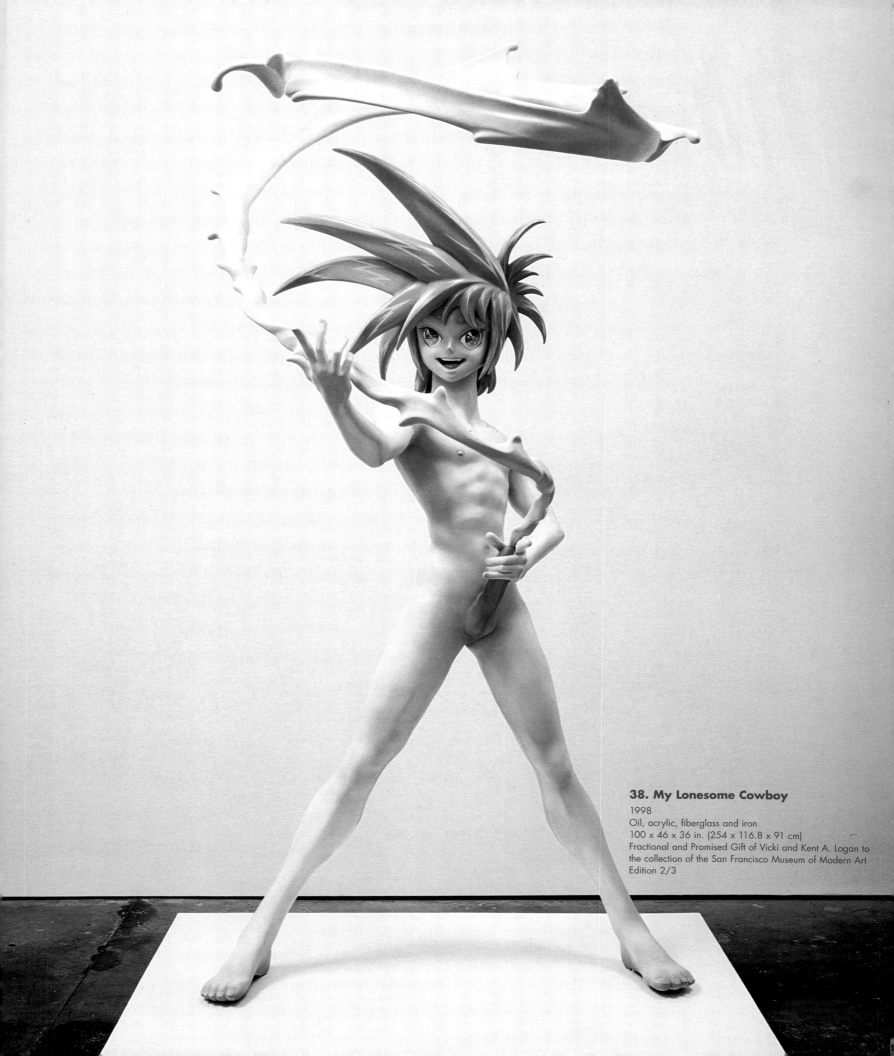

38. My Lonesome Cowboy
1998
Oil, acrylic, fiberglass and iron
100 x 46 x 36 in. (254 x 116.8 x 91 cm)
Fractional and Promised Gift of Vicki and Kent A. Logan to
the collection of the San Francisco Museum of Modern Art
Edition 2/3

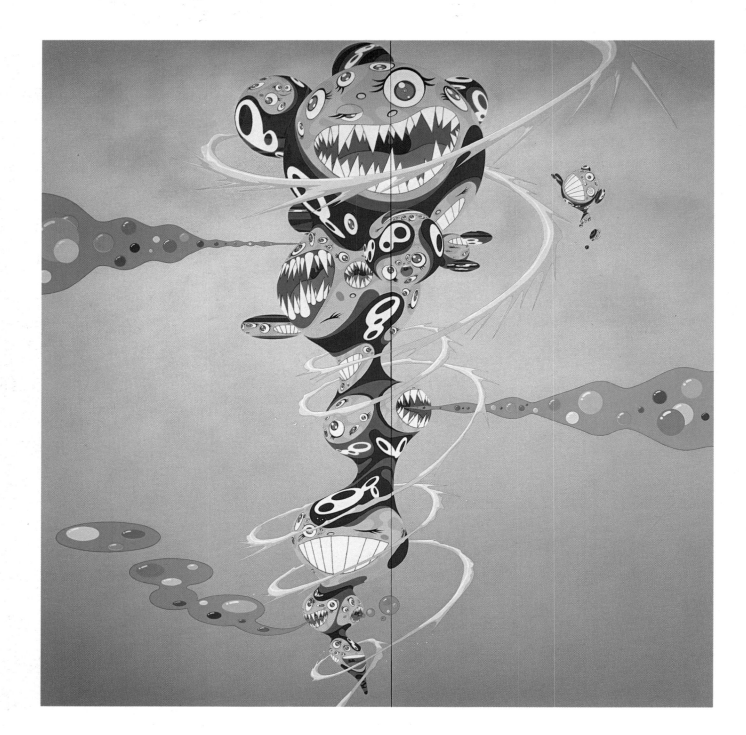

39. The Castle of Tin Tin
1998
Acrylic on canvas on board
120 x 120 in. (300 x 300 cm)
Private Collection, Los Angeles;
courtesy of Blum & Poe, Santa Monica,
and Tomio Koyama Gallery, Tokyo

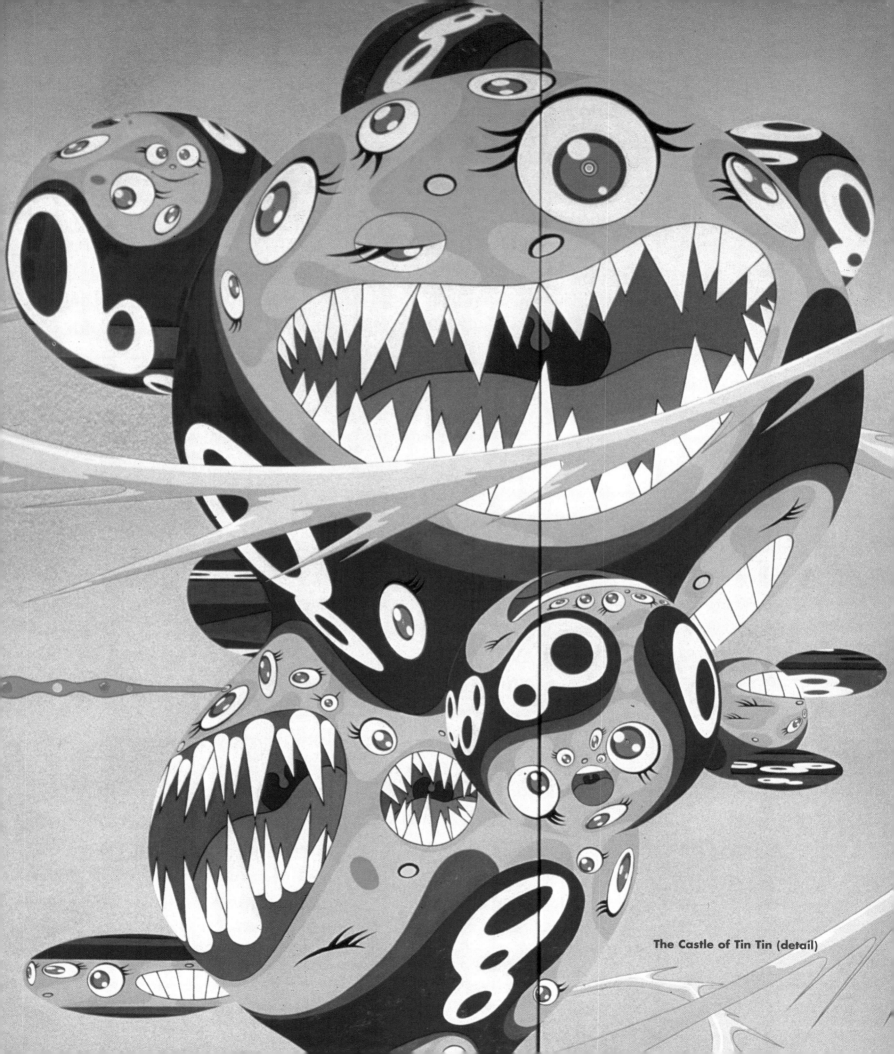

The Castle of Tin Tin (detail)

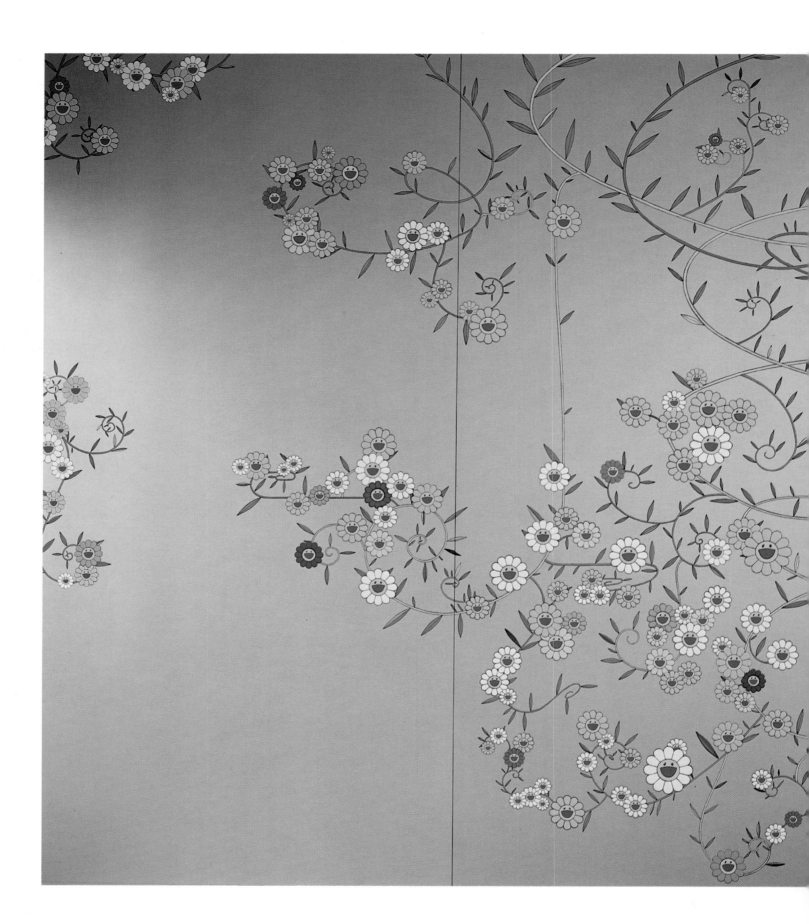

40. Cosmos
1998
Acrylic on canvas on board
60 x 120 in. (150 x 300 cm)
Courtesy of the artist and
Tomio Koyama Gallery, Tokyo

41. Merry Go Round
1995
Vinyl chloride and helium
36 in. (91 cm) circumference
Courtesy of Tomio Koyama Gallery, Tokyo

42. GuruGuru
1998
Vinyl chloride and helium
113 x 106 in. (338 x 269 cm)
Courtesy of the artist and
Tomio Koyama Gallery, Tokyo

Products

Puka Puka

Mr. DOB dolls

Mr. DOB telephone strap

Mr. DOB key chain

Mr. DOB mouse pad

Mr. DOB watch

Green Eyes Stickers

Maquette for DOB in the Strange Forest

Maquettes for inflatables

Green Eyes

Mr. DOB inflatable

Various t-shirts

DOB in Wonderland Poster

Patata

727

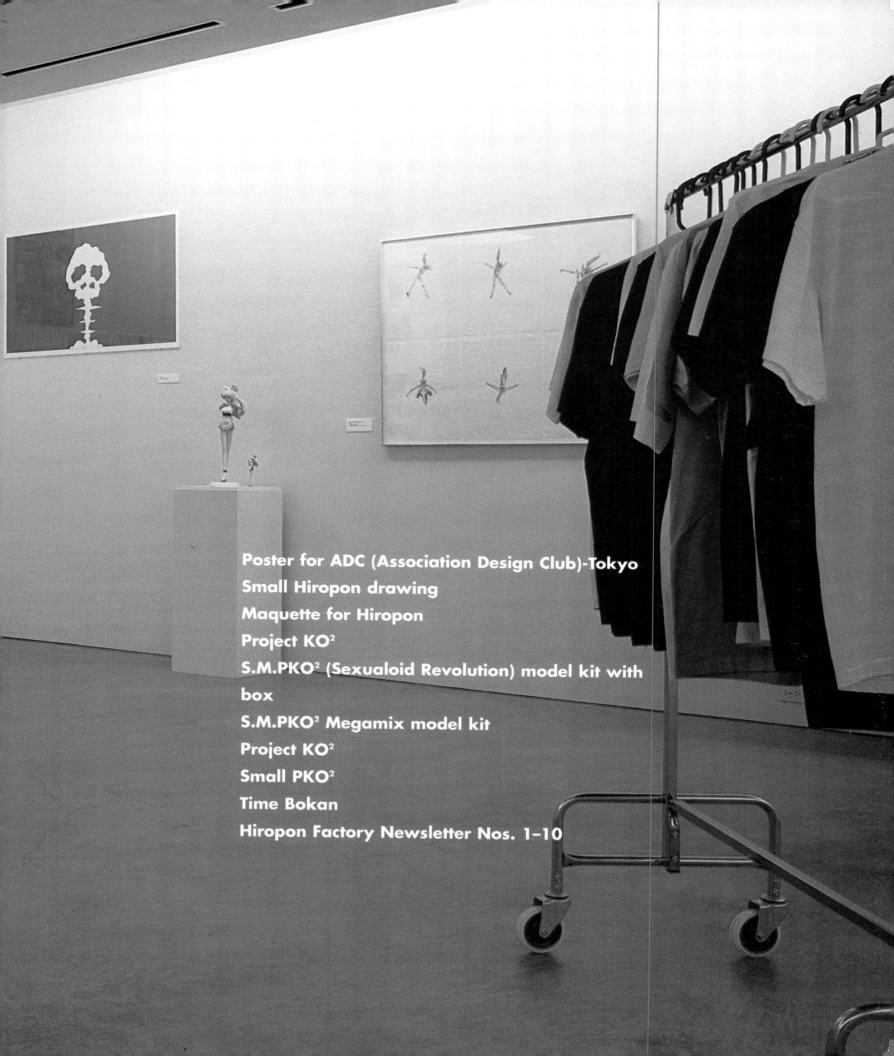

Poster for ADC (Association Design Club)-Tokyo
Small Hiropon drawing
Maquette for Hiropon
Project KO2
S.M.PKO2 (Sexualoid Revolution) model kit with box
S.M.PKO2 Megamix model kit
Project KO2
Small PKO2
Time Bokan
Hiropon Factory Newsletter Nos. 1–10

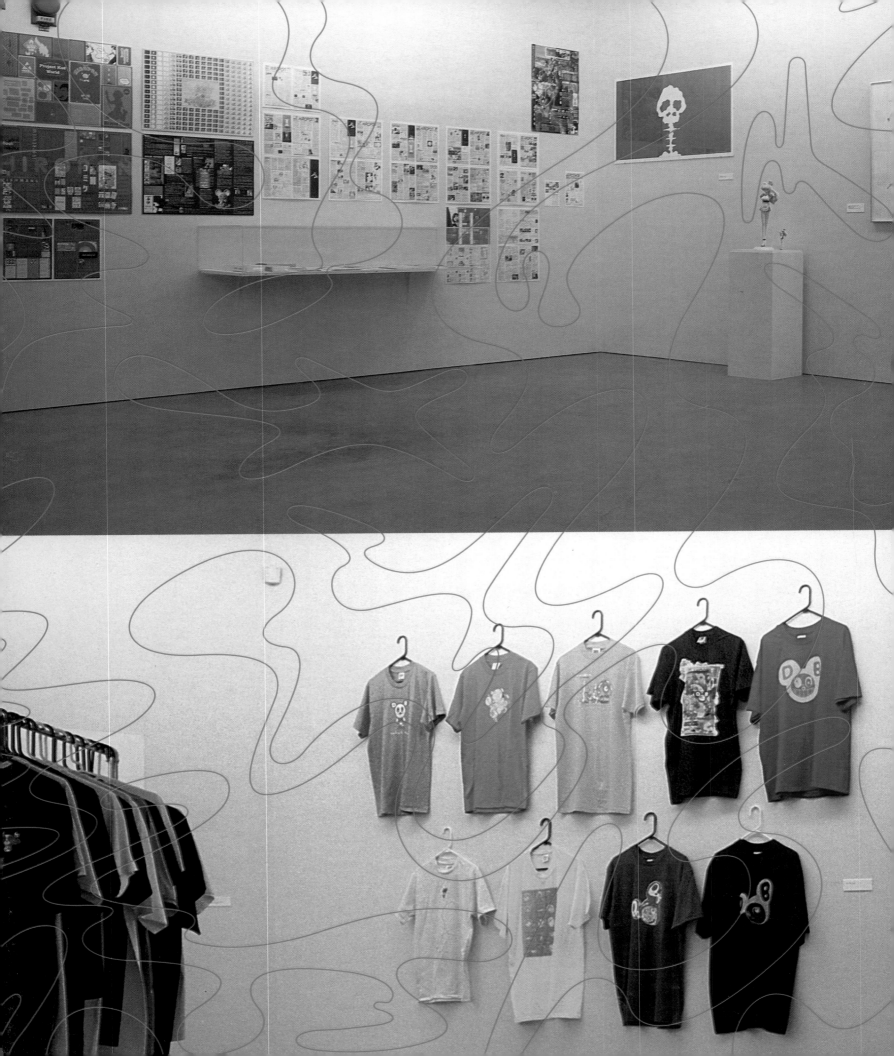

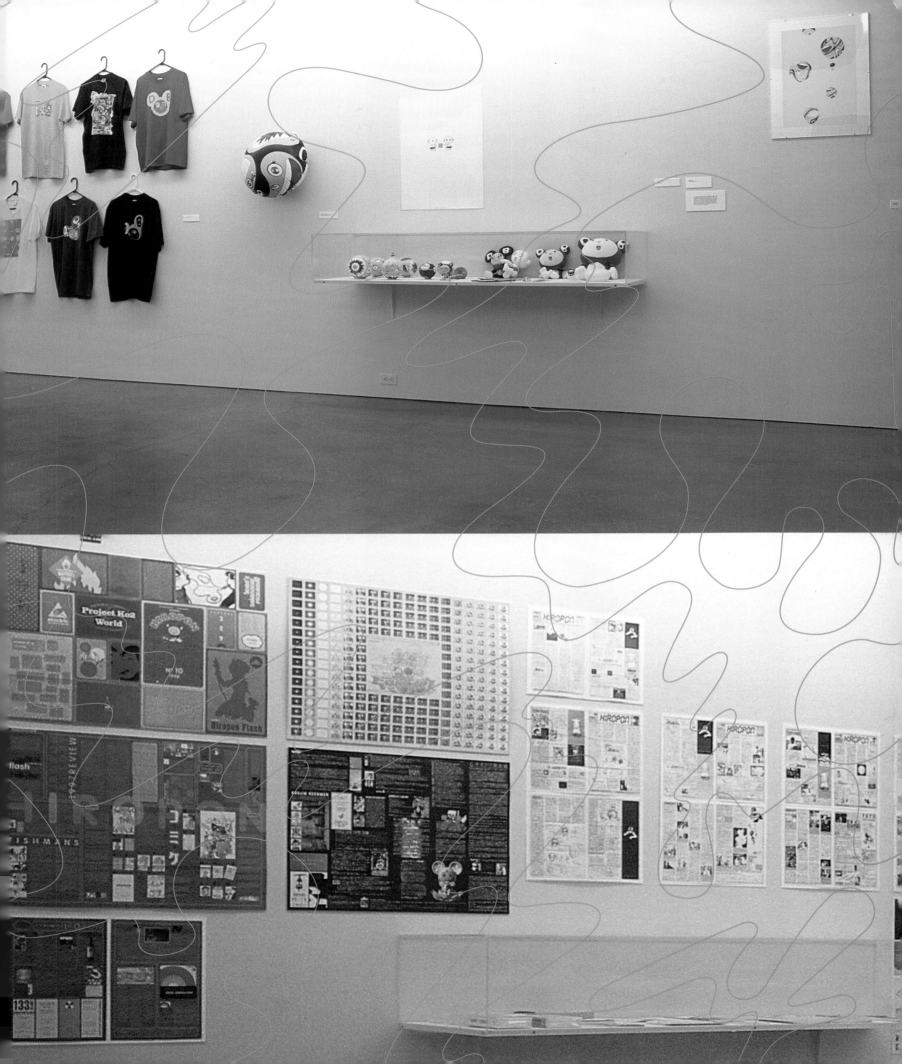

Exhibitions and Selected Bibliography

Compiled by Lisa Hatchadoorian

Born in Tokyo, 1962

Lives and works in Tokyo and New York

Education

1986 BFA, Tokyo National University of Fine Arts and Music, Department of Traditional Japanese Painting (*Nihon-ga*)

1988 MFA, Tokyo National University of Fine Arts and Music

1993 PhD, Tokyo National University of Fine Arts and Music

Solo Exhibitions

1989 Gallery Ginza Surugadai, Tokyo

1991 Röntgen Kunst Institut, Tokyo

Aoi Gallery, Osaka

Gallery Aries, Tokyo

I Am Against Being for It, Hosomi Gallery Contemporary, Tokyo

Art Gallery at Tokyo National University of Fine Arts and Music, Tokyo

1992 *Wild, Wild,* Röntgen Kunst Institut, Tokyo

NICAF 92, Shiraishi Contemporary Art, Inc., Tokyo

1993 Nasubi Gallery, Tokyo

A Very Merry Unbirthday!, Hiroshima City Museum of Contemporary Art, Hiroshima

A Romantic Evening, Gallery Cellar, Nagoya

1994 *Which Is Tomorrow?—Fall in Love,* SCAI The Bathhouse, Shiraishi Contemporary Art, Inc., Tokyo

Azami, Kikyo, Ominaeshi, Aoi Gallery, Tokyo

Fujisan, Gallery Koto, Okayama, Japan

1995 Emmanuel Perrotin, Paris

Crazy Z, SCAI The Bathhouse, Shiraishi Contemporary Art, Inc., Tokyo

Niji, Gallery Koto, Okayama, Japan

Yngtingagatan 1, Stockholm

1996 Feature, Inc., New York

A Very Merry Unbirthday, To You, To Me!, Ginza Komatsu, Tokyo

Gavin Brown's Enterprise, New York

727, Tomio Koyama Gallery, Tokyo

Gallery Koto, Okayama, Japan

Konnichiwa, Mr. DOB, Kirin Art Plaza, Osaka

7272, Aoi Gallery, Osaka

1997 Emmanuel Perrotin, Paris

University Art Gallery, State University of New York, Buffalo

Blum & Poe, Santa Monica

1998 Feature, Inc., New York

Back Beat, Blum & Poe, Santa Monica

Super Flat & Back Beat, Tomio Koyama Gallery, Tokyo

Moreover, DOB Raises His Hand, Sagacho bis, Tokyo

1999 *Super Flat,* Marianne Boesky Gallery, New York

Takashi Murakami: DOB in the Strange Forest, Parco Gallery, Tokyo

Group Exhibitions

1991 *Jan Hoet in Tsurugi,* Tsurugi-cho, Ishikawa, Japan

Jan Hoet's Vision, Art Gallery Artium, Fukuoka, Japan

1992 *Artist's Shop 92,* Sai Gallery, Osaka

Mars Gallery, Tokyo

1st Transart Annual Painting/Crossing, Bellini Hill Gallery, Yokohama

Nakamura and Murakami, Ozone, Seoul; Shiraishi Contemporary Art, Inc., Tokyo; *NICAF 93,* Aoi Gallery, Yokohama

Anomaly, Röntgen Kunst Institut, Tokyo

Nakamura and Murakami, Metaria Square Hotel, Osaka

Tama Vivant 92, Seed Hall, Shibuya Seibu, Tokyo

Floating Gallery Vol. 1, Tsukishima Warehouse, Tokyo

1993 *Malaria Art Show, Vol. 1,* February 1st Festival, Tokyo

90

Artist's Shop 93, Sai Gallery, Osaka

OO Collaboration, Sagacho Exhibition Space, Tokyo

Art Today 93: Neo-Japanology, Sezon Museum of Modern Art, Karuizawa, Nagano

Beyond the Nihon-ga: An Aspect of Contemporary Japanese Painting, Tokyo Metropolitan Art Museum, Tokyo

The Exhibition for Exhibitions, Kyoto Shijo Gallery, Kyoto

The Ginburart, Ginza, Tokyo

Malaria Art Show, Vol. 4: Decorative, Tokyo

1994 *VOCA 94 (The Vision of Contemporary Art)*, Ueno Royal Museum, Tokyo

Lest We Forget: On Nostalgia, The Gallery at Takashimaya, New York

The Youthful Time of Japanese Nihon-ga Artists from Tarikan and Shunso to Mr. DOB, Koriyama City Museum of Art, Fukushima, Japan

Shinjuku Syonen Art, Shinjuku Kabuki-cho, Tokyo

1995 *Transculture*, 46th Venice Biennale, Venice; Naoshima Contemporary Art Museum, Kagawa, Japan

Japan Today, Louisiana Museum of Modern Art, Humlebaek, Denmark; Kunstnernes Hus, Olso; Liljevalchs Konsthall, Stockholm; Wäinö Aaltonen Museum of Art, Turku, Finland; Museum für Angewandte Kunst, Vienna; Deichtorhallen, Hamburg

Cutting Up, Max Protetch Gallery, New York

Incidental Alterations: P.S. 1 Studio Artists 1994–95, Angel Orensanz Foundation, New York

Art Space Hap, Hiroshima

1996 *Tokyo Pop*, Hiratsuka Municipal Museum of Art, Kanagawa, Japan

The 2nd Asia-Pacific Triennial 1996, Queensland Art Gallery, Brisbane

Romper Room, Thread Waxing Space, New York; DiverseWorks, Houston

Ironic Fantasy, Miyagi Museum of Art, Sendai, Japan

Sharaku Interpreted by Japan's Contemporary Artists, The Japan Foundation Forum, Tokyo

1997 *Flying Buttress Please*, Torch Gallery, Amsterdam

Super Body, Tomio Koyama Gallery, Tokyo

Need for Speed, Grazer Kunstverein, Graz, Austria

Cities on the Move, The Secession, Vienna; CAPC Musée d'Art Contemporain de Bordeaux; P.S. 1 Contemporary Art Center, New York; Louisiana Museum of Modern Art, Humlebaek, Denmark; Hayward Gallery, London; Museum of Modern Art, Helsinki

Japanese Contemporary Art Exhibition, National Museum of Contemporary Art, Seoul

Singularity in Plurality, Yokohama Civic Art Gallery, Kanagawa, Japan

1998 *Pop Surrealism*, Aldrich Museum of Contemporary Art, Ridgefield, Connecticut

People, Places and Things, Marianne Boesky Gallery, New York

Art Is Fun 9: Hand Craft and Time Craft, Hara Museum ARC, Tokyo

So What? An Exhibition of Contemporary Japanese Art, École Nationale Supérieure des Beaux-Arts, Paris

Abstract Painting Once Removed, Contemporary Arts Museum, Houston; Kemper Museum of Contemporary Art, Kansas City, Missouri

The Manga Age, Museum of Contemporary Art, Tokyo

The 3rd Nouméa Biennial of Contemporary Art, Nouméa, New Caledonia

Fifty Years of Japanese Lifestyle, Postwar Fashion and Design, Utsunomiya Museum of Art, Tochigi, Japan; Hiroshima Municipal Museum of Contemporary Art, Hiroshima

Tastes and Pursuits: Japanese Art in the 1990s, National Gallery of Modern Art, New Delhi, India; Metropolitan Museum of Manila, The Philippines

1999 *New Modernism for a New Millennium: Works by Contemporary Asian Artists from the Logan Collection*, Limn Gallery, San Francisco

Painting for Joy: New Japanese Painting in the 1990's, Japan Foundation Forum, Tokyo

Selected Bibliography

1991 Friis-Hansen, Dana, "Art Picks: Takashi Murakami," *The Japan Times Weekly*, December 14.

Sawaragi, Noi, "Blow Up," in *Takashi Murakami 1989–1991*, exhibition catalogue, Tokyo: Gallery Aries.

Yusuke, Minami, "RP by TM," in *I Am Against Being for It*, exhibition brochure, Tokyo: Hosomi Contemporary Gallery.

1992 Friis-Hansen, Dana, "Japan Today: Empire of Goods, Young Japanese Artists and the Commodity Culture," *Flash Art* 25 (March/April): 78–81.

____. "Takashi Murakami" in *NICAF 92*, exhibition brochure, Yokohama: Shiraishi Contemporary Art, Inc.

____. "Art Picks: Takashi Murakami," *The Japan Times Weekly*, March 7.

Nanjo, Fumio, and Noi Sawaragi, "Japan Today: Dangerously Cute," *Flash Art* 25 (March/April): 75–77.

Nishihara, Min, "Rifts," in *Nakamura and Murakami*, exhibition catalogue, Seoul, Tokyo and Yokohama: Ozone, Shiraishi Contemporary Art, Inc., and *NICAF 93*, Aoi Gallery

Sawargi, Noi, "Lollipop: The Smallest Possible Form of Life," *Bijutsu Techo* 44 (March): 86–92.

1993 *Art Today 93*, exhibition catalogue, Tokyo: Sezon Museum of Art.

Brown, Azby, "Techno-infantilism and the Pure Environment," *Art and Text* (Australia), no. 44 (January): 30–32.

Dehara, Hitoshi, "The Work of Art in an Age Without Hierarchy," in *A Very Merry Unbirthday!*, exhibition brochure, Hiroshima: Hiroshima City Museum of Contemporary Art.

Koplos, Janet, "Rockets and Refrigerators," *Art in America* 81 (July): 66–73.

1994 Bellars, Peter, "If You Can't Beat 'Em," *Asahi Evening News*, July 17.

Gumpert, Lynn, and Tom Sokolowski, *Lest We Forget: On Nostalgia*, exhibition catalogue, New York: The Gallery at Takashimaya.

Matsui, Midori, "Murakami Takashi: Nihilist Agonistes," in *Takashi Murakami: Which Is Tomorrow?—Fall in Love*, exhibition catalogue, Tokyo: SCAI The Bathhouse.

Munroe, Alexandra, "Hinomaru Illumination: Japanese Art of the 1990's," in *Japanese Art After 1945: Scream Against the Sky*, exhibition catalogue, New York: Abrams: 341.

1995 Friis-Hansen, Dana, and Fumio Nanjo, *Transculture*, exhibition catalogue, Tokyo: The Japan Foundation, Fukutake Science and Culture Foundation.

Friis-Hansen, Dana, "Portrait of the Young Japanese Artist as a Fanatic," *Louisiana Revy* 35 (June), and in *Japan Today*, exhibition catalogue, Humlebaek, Denmark: The Louisiana Museum of Modern Art.

Nielson, Tone O., "Takashi Murakami," *Louisiana Revy* 35 (June), and in *Japan Today*, exhibition catalogue, Humlebaek, Denmark: The Louisiana Museum of Modern Art: 55.

Nilsson, Håkan, "Japan Today at Louisiana," *Material* 27 (Autumn): 6.

1996 Higa, Karin, "Some Thoughts on National and Cultural Identity: Art by Contemporary Japanese and Japanese-American Artists," *Art Journal* 55 (Fall): 6–13.

Matsui, Midori, "Takashi Murakami," *The 2nd Asia-Pacific Triennial 1996*, exhibition catalogue, Brisbane: Queensland Art Gallery.

Shin, Misa, "Vitamin Culture," *DiBi DiBi Paper*, (April): 10.

Tokyo Pop, exhibition catalogue, Kanagawa: Hiratsuka Municipal Museum of Art.

1997 Folland, Tom, "Hello Mr. DOB," in *Takashi Murakami*, exhibition brochure, Buffalo: SUNY, Buffalo, Art Gallery.

Hara, Makiko, "Contemporary Japanese Art: Young Artists, Consumer Culture and Internationalization," *Parachute* (October/December): 36–42.

Matsui, Midori, "Tokyo Pop," *Flash Art* 30 (November/December): 110.

____. "Memory and Desire," *Japan Today: Kunst Fotographie Design*, exhibition catalogue, Vienna: Museum für Angewandte Kunst.

Pagel, David, "Paintings in Midst of Generational Conflict," *Los Angeles Times*, August 1: F-28.

Obrist, Hans-Ulrich, and Hou Hanru, eds., *Cities on the Move*, exhibition catalogue, Vienna and Bordeaux: The Secession and CAPC Musée d'Art Contemporain de Bordeaux.

Sawaragi, Noi, "Takashi Murakami," *World Art* (Summer): 76.

Singularity in Plurality, exhibition catalogue, Yokohama City, Japan: Yokohama Civic Art Gallery.

1998 Darling, Michael, "The Fire Hose Lariats of Takashi Murakami," *dART International* 1 (Fall): 26.

DiPietro, Monty, "Takashi Murakami at the Tomio Koyama Gallery," *Asahi Evening News*, September 24: 11.

Donai Yanen! La Création Contemporaine au Japon, exhibition catalogue, Paris: Ecole Nationale Supérieure des Beaux-Arts.

Fifty Years of Japanese Lifestyle, Postwar Fashion and Design, exhibition catalogue, Tochigi and Hiroshima: Utsunomiya Museum of Art and Hiroshima Municipal Museum of Contemporary Art.

Friis-Hansen, Dana, "Takashi Murakami," *Grand Street* 65: 216–21.

Goldberg, Itzhak, "Art et Humour," *Beaux-Arts Magazine* 171 (August): 36–43.

Hickey, Dave, "The Best of 1998," *Artforum* 37 (December): 94–95.

Joyce, Julie, "Star Blazers: New Pop from Japan," *Art issues,* no. 54 (September/October): 23–25.

Matsui, Midori, "Takashi Murakami," *Index* 3 (November/December): 44–51.

Molinari, Guido, "Takashi Murakami," *Flash Art* 31 (March/April): 106.

Pagel, David, *Los Angeles Times*, July 3: F-26.

Tastes and Pursuits: Japanese Art in the 1990's, exhibition catalogue, Tokyo: The Japan Foundation.

The 3rd Nouméa Biennial of Contemporary Art, exhibition catalogue, Nouméa, New Caledonia.

Tumlir, Jan, "Takashi Murakami at Blum & Poe," *LA Weekly*, July 17–23: 61.

1999 "Summer Preview," *Artforum* 37 (May): 53.

"Takashi Murakami," *Art Press* 245 (April): 72–73.

DiPietro, Monty, "Takashi Murakami at the Parco Gallery," *The Japan Times,* May 9: 14.

Fujimori, Manami, *Bijutsu Techo* 51 (April): 132–33.

Gomez, Edward M., "The Fine Art of Biting into Japanese Culture," *The New York Times*, July 18: 33.

Greene, David, "Exposure: Takashi Murakami," *Spin* (March): 64–65.

Kimmelman, Michael, "The Hudson Valley, Inside and Out," *The New York Times*, July 30: E-37.

Kusumi, Kiyoshi, "Takashi Murakami," *Bijutsu Techo* 51 (May): 125–42.

Levin, Kim, "Voice Choices: Takashi Murakami," *The Village Voice* 64, February 16: 86, 88.

Murakami, Takashi, Interview with Paul McCarthy, *Super Flat*, exhibition poster, New York: Marianne Boesky Gallery.

Murakami, Takashi, "POP+OTAKU=PO+KU," *Big*, no. 21.

Pederson, Victoria, "Reviews," *Paper* (February): 136.

Pinchbeck, Daniel, "Our Choice of Contemporary Galleries in New York: A Montage of Photo Exhibitions," *The Art Newspaper* 10 (February): 72.

Shelley, Ward, and Erik Bakke, "Mob Rule: Sculpture after Hanson," *NY Arts* 4: 10–13.

Smith, Roberta, "Takashi Murakami," *The New York Times*, February 5: B-35.

Grants and Awards

1994–95 Asian Cultural Council Fellowship, P.S. 1 International Studio Program, New York

Acknowledgments

As with any exhibition, *Takashi Murakami: The Meaning of the Nonsense of the Meaning* would not have been possible without the hard work of many individuals. Our greatest appreciation goes to Leon Botstein, President of Bard College, for his support of the CCS and for fostering a climate of experimentation that allows for projects such as this one. We would like to thank Dimitri Papadimitriou, Executive Vice-President of Bard College, for his constant encouragement, guidance and genuine interest in the Museum's activities. We are grateful to Marcia Acita, Assistant Director of the Museum, for her untiring energy, dedication and attention to detail; Ellen Hobin, Administrative Assistant, for her sense of humor and for keeping a step ahead of the process; and Lisa Hatchadoorian, Curatorial Intern, for her invaluable assistance in compiling and checking catalogue information. Thanks go to our skillful installation crew—Mark DeLura, Jonathan Goode, Nick Nehez and preparator Dean Lavin—and Takashi Murakami's assistant Mr. for their long hours of hard work. Samantha Pawley, Assistant Registrar, helped in moments of need, and Susan Leonard, Librarian, provided valuable research assistance. Debra Pemstein, Vice President of Development and Alumni Affairs, Pam Doyle, Manager of Special Projects, Judy Samoff, Dean of Programs, and Ann Gabler and Judy Hester from the Grants Office were tireless in their fundraising efforts. Special thanks go to Norton Batkin, Director of the CCS Graduate Program, for being such a terrific colleague.

Takashi Murakami is supported by a dedicated network of dealers. We thank them for their crucial assistance in all phases of mounting this exhibition. They are: Tim Blum, Jeff Poe and Kirsten Biller of Blum & Poe, Santa Monica; Tomio Koyama and Misako Niida of Tomio Koyama Gallery, Tokyo; and Marianne Boesky of Marianne Boesky Gallery, New York. We tip our hats to Hudson at Feature, who showed Murakami in New York early on.

For their work on this catalogue, we wish to acknowledge Store A for their expert editing, Takaya Goto for his wonderful design, and Steve Lafreniere for his production assistance. We are grateful to Midori Matsui for contributing her important essay, and Ginger Shore, Director of Publications and Public Relations, for her advice on the catalogue.

Finally, we would like to thank Takashi Murakami for his inspirational body of work. It has been a joy to work with an artist of such wit and intelligence.

Dana Friis-Hansen, *Chief Curator, Austin Museum of Art, Texas*
Amada Cruz, *Director, Center for Curatorial Studies Museum, Bard College*
Co-curators of the exhibition

94

Photograph credits

Douglas Baz: plates 5 (text photos), 9, 18, 20, 21, 30, 35, 40-42, 44; installation views, pp. 60-61, 86-89

Anthony Cuñha: plates 10, 11

Rick Harman: plate 1

Masakasu Kunimori: plate 5 (portraits)

©Leiji Matsumoto, Toei Animation: fig. 9 (Matsui)

©1983 The Metropolitan Museum of Art: fig. 6 (Matsui), fig. 4 (Friis-Hansen); ©1994: figs. 7, 8 (Matsui)

©Shogakukan Publishing: fig. 10 (Matsui)

Jean Vong: plate 15

©1997 The Andy Warhol Foundation for the Visual Arts/ARS, New York; photographer, Philipp Scholz Ritterman: fig. 1 (Cruz)

Joshua White: plates 12-4, 17, 26, 34, 36-38

Production credits

Friis-Hansen, fig. 5
Model remixed by Masahiko Asano and MA Modeling Laboratory

pl. 5. Kase Taishuu Project
Portrait photography by Masakazu Kunimori

pl. 15. Miss KO²
1/5 model made by Bome (Kaiyodo), full-scale model made by Toru Saegusa (Shadow Moon)

pl. 16. Hiropon
1/5 model made by Bome (Kaiyodo) and Takeshi Shirai (Kaiyodo), full-scale model made by Toru Saegusa (Shadow Moon), supported by Kirin Art Plaza

pl. 38. My Lonesome Cowboy
Full-scale model made by Fuyuki Shinada (Vi-shop), advised by Takeshi Shirai (Kaiyodo) and Syuichi Miyawaki (Kaiyodo)